FURRIES FUREVER

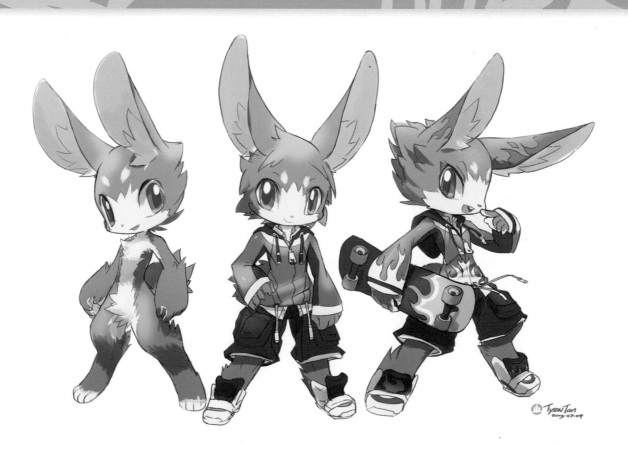

FURRIES FUREVER

Draw and Color Anthro Characters in a Variety of Styles

Jared Hodges and Lindsay Cibos

IMPACT

CINCINNATI, OHIO
impact-books.com

Fystilago
Kristen Plescow

Contents

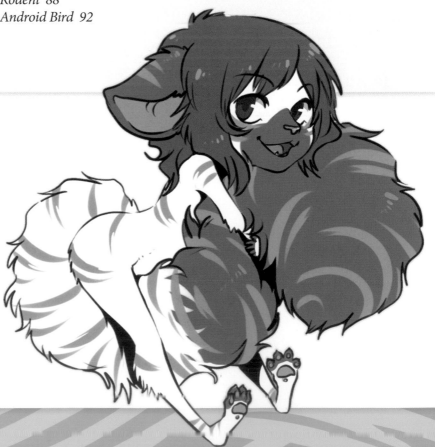

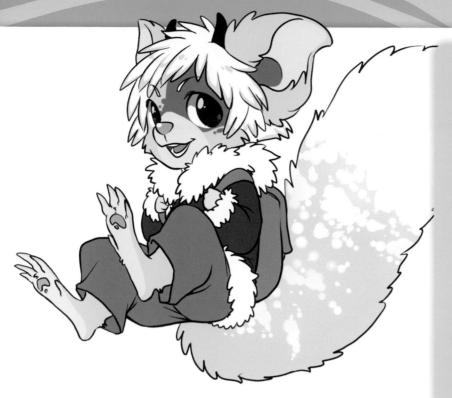

Some Words to Know

Anthropomorph: A nonhuman thing displaying human characteristics. For example, an anthropomorphic animal is an animal with human characteristics. The term comes from the Greek word *anthropos* (meaning human being) and *morphe* (meaning shape).

Anthro: Shortened term for anthropomorphic animal.

Furries: Another term for anthropomorphic animals. Refers to any type of anthropomorphic animal, even those without fur. It can also be used to describe people who are fans of furry characters.

Fursona: A person's animal avatar or personal character.

Scalies: Anthropomorphic reptiles and reptile-like creatures, both real and fantastical, including amphibians, dinosaurs and dragons.

Biped: Something that moves on two feet.

Quadruped: Something that moves on four legs.

Plantigrade: Walking on the soles of the foot.

Digitigrade: Walking on the toes.

Unguligrade: Walking on hooves.

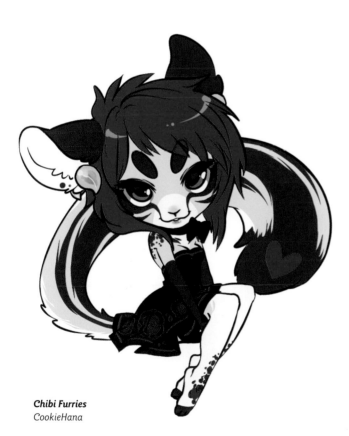

Chibi Furries
CookieHana

Introduction

Furry art is a triumph of imaginative character design. It remixes exotic animal aspects with the familiar human form in new and interesting ways to create fascinating, never-before-seen creatures. The furry body itself can become a canvas as artists adorn it with not only clothing, but patterns, designs, symbols, color washes and other elements.

Although the concept of a humanoid animal hybrid may seem absurd, through an artist's skillful depiction, furries can be fun and adorable, hulking and fearsome, or even convincingly lifelike, depending on the style! That's what's great about art. It's yours, and you get to decide how you want to make it. Style is simply an individual's approach to art. Its basis can come from culture, observation and/or pure invention (or a blend of all three!). Style consists of whatever elements you choose to express or emphasize in your work, such as drawing and coloring techniques, the level of detail, themes and topics of exploration and even characters' proportions.

Throughout the pages of this book, you'll meet an impressively diverse and creative assortment of artists from all around the world, each with their own stylistic approach to creating furry artwork. As the artists share inspiration and insight into how they draw and color anthropomorphic characters, you'll discover how each creates a distinctive impression. While their techniques range from meticulously detailed to simple and cartoony, or from cleanly inked lines to lineless paintings, the end result is lively furries ready to leap off the page!

Every artist in this book has different strengths and aptitudes. They have different views, went to different schools, pull inspiration from different sources and learned to draw by different means. Some are designers who pursue a degree of realism in their depictions, while others sway toward fantasy. Some work entirely digitally, equipped with a laptop and a graphics tablet, while others prefer traditional tools like pencils, markers and paints. Yet, despite their differences, they all produce fantastic imaginative art that's universally recognized as furry.

If you're just starting out, you may not have your own defined style yet. That's okay! We're here to help you discover the approach to drawing and coloring an anthropomorphic character that works best for you. As you practice, your style will develop naturally. The only things limiting you are your imagination and technical abilities. Fortunately, with time and effort, you can expand whatever talent you start with and create your own ideal reality (at least on a sketch pad)!

So what are you waiting for? Grab your art supplies and let's draw furries!

Sound of the Forest
Tyson Tan

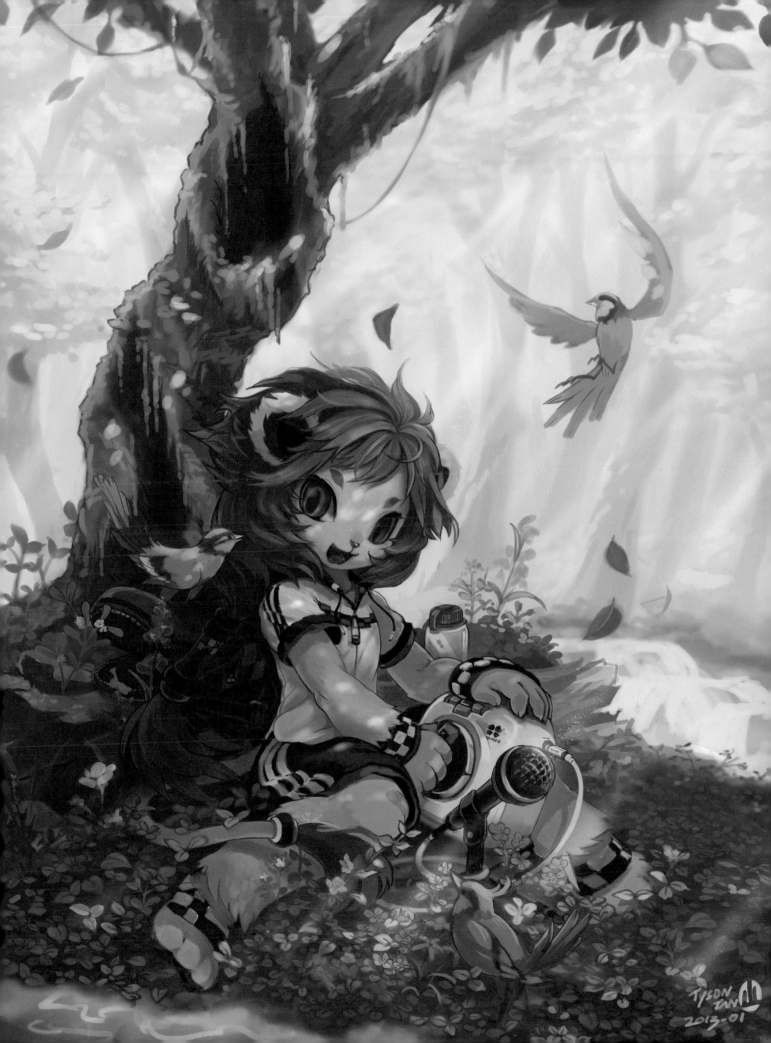

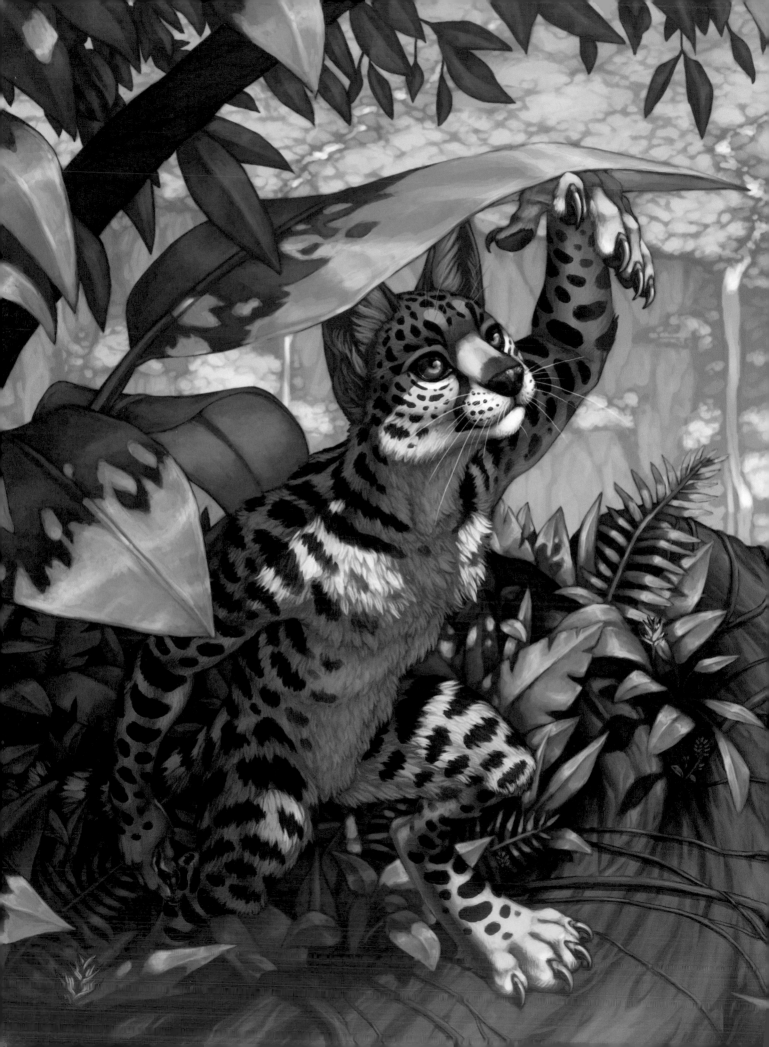

CHAPTER ONE
Katie Hofgard

Katie Hofgard is a painter and illustrator with a BFA in illustration from the Rocky Mountain College of Art and Design and has a love for animals both fantastic and real. She is a full-time freelance illustrator, focusing mostly on private commissioned work. She has also done work for the Werewolf Calendar, some online games and designed illustrative logos for several companies. She grew up in the Rocky Mountains of Colorado, running around in the thick pine forests surrounding her isolated mountain home with her dog by her side. Nature is a strong source of inspiration for her, and she strives to create works that show the beauty of our planet with a fantastical twist that catches the eye and inspires the heart and mind.

Precipice of Light
Photoshop

Style

I try my best to balance exaggeration and believability in my art, to create imaginative depictions of fantasy that feel real. I find applying traditional painting techniques for realism to slightly cartoonish drawings is a pleasant combination. I really enjoy posing characters in the midst of dynamic action, as if a still frame in a movie or a panel in a comic, always seeking the most interesting angle for even the plainest of character actions. I tend to favor dark, dramatic color schemes, much like one of my favorite classical artists, Caravaggio, but with more saturated colors.

I think animals in art are a great analogue for human personalities and behavior, as well as being captivating on their own. Every species has its own unique aspects, and each individual has its own personality. Bat species are among my favorite animals. They're so vital to the ecosystem and so amazing (the only mammals to evolve true sustained flight!), yet they're often feared and misunderstood. I also really love the animals closest to us humans, the domestic species that have been with us for thousands of years—dogs, cats and horses, all animals we are so familiar with and that have been stalwart companions and helpers. From the waggly excited personality of the family dog to the powerful, hungry look of a wild lion—all animals inspire me when I paint!

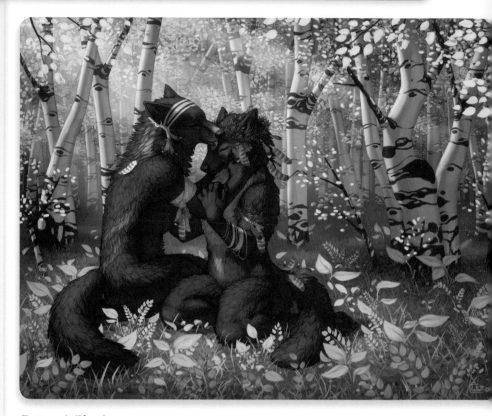

Autumn's Blessing
Photoshop

Painted for the 2013 Werewolf Calendar. For this piece, I wanted the golden glow of the aspen grove to set off the dark colors of the characters. The accent colors of red and blue appear only on the clothing of the two wolves to help draw the eye to them in the midst of the uniform yellows of the autumn trees. The overall warmth of the colors heightens the emotional warmth as the two share a private moment in this secluded forest glen.

Azzari Portrait
Photoshop

Not all dragons are stoic and noble! I wanted to show off the goofy personality of this fuzzy, blue dragon character with a silly grin and waggling tongue. An unusual expression for an unusual dragon.

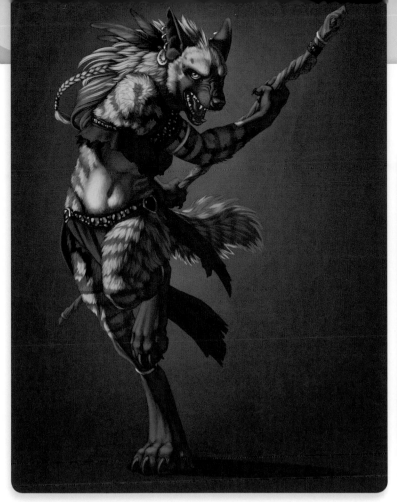

Challenge Accepted
Photoshop

This hyena character embodies the peak of power: strong, skilled, smart and quick. I wanted to show off not only her visual design but also her prowess as a warrior. Her lunging pose and staff drawn back to strike convey she's ready for a fight!

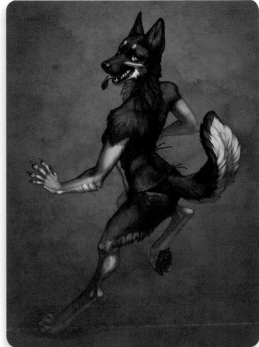

Toffee
Photoshop

What dog doesn't love a day at the beach? This cute canine gal is just like any playful pup who wants to romp in the sun. I used purples to convey a lighter mood, which went well with her golden- and red-brown fur coat.

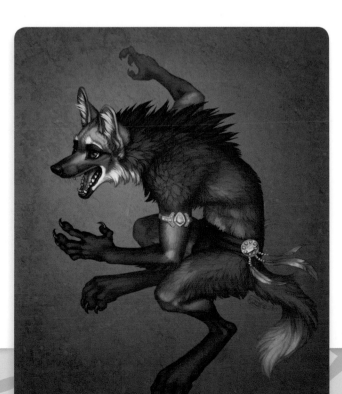

Cortez
Photoshop

Maned wolves are interesting animals. They aren't even wolves, despite their name, and if you've ever seen one they're quite leggy and awkward for a canid! They have an amazing rust color that I find really appealing and adorable huge ears.

Fun Fact

The term *furry*, is used to refer to anthropomorphic animals and the fandom was coined in the 1980s.

Artist's Toolkit

I start and finish all my work on my computer. Painting digitally means I have a smaller work space than if I painted traditionally, which is convenient for a compact living space. Working in front of a monitor all day can be hard on the eyes, so I sketch on dark-colored backgrounds to ease my eye stress. When it comes time to color, I keep it loose as long as I can, zooming out to see the entire painting, using large brushes and singular strokes to block in the basics of each piece. It isn't until the final hours of a painting that the details come into play. I want each piece to look good as a whole and to have fun details to find up close.

Materials list

- Home-built PC
- Nikon Coolpix (for taking reference photos)
- Photoshop CS6
- Wacom Intuos3 tablet

Work Space

No matter what medium you work in, it's important to be comfortable, especially if you're drawing and painting for long hours. If you're working digitally, arrange your monitor and tablet so you don't have to hunch over to use them. If you're working traditionally, look into getting a drafting table with an adjustable height/inclined surface to avoid bending over your work uncomfortably. It doesn't hurt to have a comfy chair too! Don't forget to take breaks to get up and stretch frequently. It will help refresh your body and mind so you can return with a fresh perspective and renewed vigor to continue painting at your best.

Wacom Intuos 3 Tablet

How to Make Your Own Brushes in Photoshop

Photoshop is a huge program that comes with libraries full of brushes, including basic round brushes that excel at many tasks. Endless varieties of specialty brushes are available online, but it can also be fun and useful to create a handful of your own brushes. Custom brushes can help you tackle tasks unique to your artistic demands and stamp your work with a signature feel found nowhere else.

Test Brush

Let's try making a new brush. We want one that can be used to block in large textured areas. It should have enough variety that you can build shapes and details off the rough texture but is controlled enough that you don't end up with a messy canvas.

Create a New File

Go to File and click New. A window will pop up asking you what size you want your file to be. Make both the width and height 300 pixels, and make sure your background color is white.

Create a Brush

Now comes the creative part! Choose solid black as your paint color, and create your brush design. Play with different brushes, and see what you like. You'll discover new textures and fun designs taking shape.

Save Your Brush

Go to Edit and click Define Brush Present to save your file as a brush. A window will pop up asking you to name your brush. Keep track of your brush names so you can find them later.

Find Your Brush

It is now safe to close your brush file. You can find your new brush by opening the brushes panel (right click on your mouse over an open file), and your brush should be at the very bottom. Select it and paint a line with it—see what it looks like!

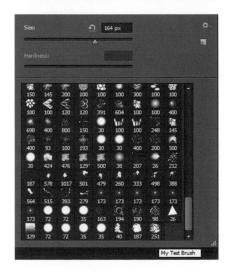

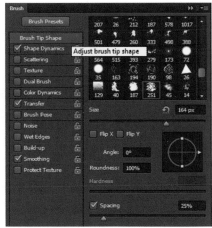

Tweak Settings

You can change how your brush looks when you paint with it by adjusting your brush presets. To bring up your brush presets, press F5 or go to Window and click Brush. A window will pop up with quite a few options. Play with these settings to find something you like.

DEMONSTRATION
Ocelot: Drawing

So you have a really cool animal character you want to paint, but you're not sure how to go about it. Making a painting involves a lot of different types of knowledge from anatomy to light and color. Here is a step-by-step process for creating an ocelot character from gesture to finished painting that condenses that knowledge to help you bring your awesome character to life!

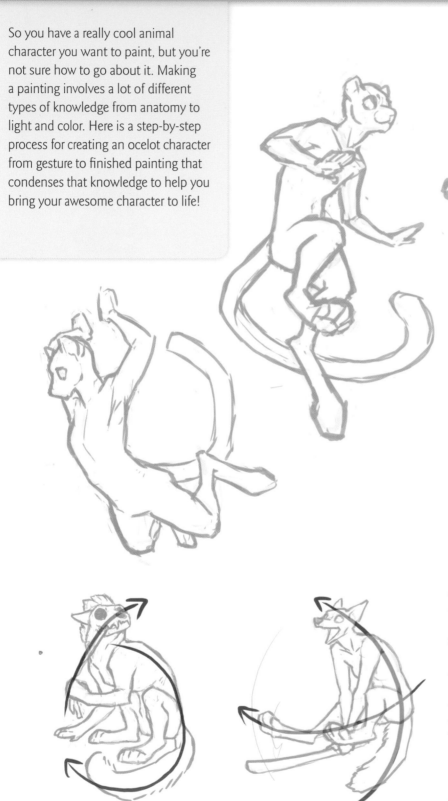
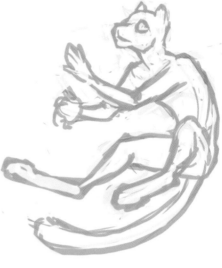

1 Do Gesture Sketches

The purpose of gesture sketches is to hash out poses for your character. Keep the sketches very quick and loose at this stage, and don't worry too much about details or even correct anatomy. Try not to spend more than ten minutes on each one; just get the idea out on paper. Building up a collection of gesture sketches will help you with future character paintings too!

If you are working digitally, use a large brush and make sure you are zoomed out; you want to be able to gauge the whole gesture visually, not just one portion of it.

2 Examine the Line of Action

As you make your gesture sketches, imagine the character as a series of lines showing the general motion. The main line of action is the spine, but you can also position the arms and legs for the liveliest action. Straight lines of action don't make for very interesting poses even if you want your character to be stationary. Adding some curve will breathe life into your character and make it seem less stiff and more organic. You can get really crazy with massive swooping lines of action to define a sprint or a high leap!

Tip: Gather Reference Photos

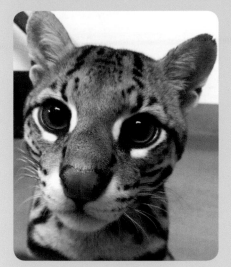

Ocelot
Photo by Kuro

References will help you refine your sketch. You can learn to draw anything if you study it! So where do you find photographs you can use for reference?

First, let's define the difference between direct referencing and indirect referencing. Direct referencing is when you copy any part of a photograph either through tracing or by eyeballing it. Indirect referencing is when you use photos to see what an animal or object looks like, but you are not directly copying any particular part of any of those photos. Instead, you make something new based off what you learned by looking at those photographs.

So what are some good reference sources? Remember that photographs, just like art, are protected by copyright. For direct reference, your safest bet is to build a library of your own photographs. Snapshots of places, objects, plants, animals, yourself, willing models, etc. can all come in handy! You can also search online for stock photography, but be sure to check with the photographer for permission to use their work. For indirect reference, you can use anything.

3 **Sketch Studies**
Once you have your reference gathered, it helps to make some sketches of parts you are unsure about, like paws or muzzles, before you start on the actual character drawing. This is a good way to get to know your subject.

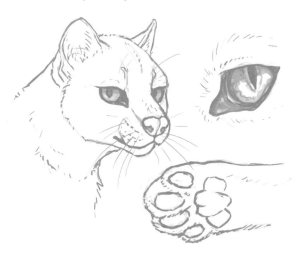

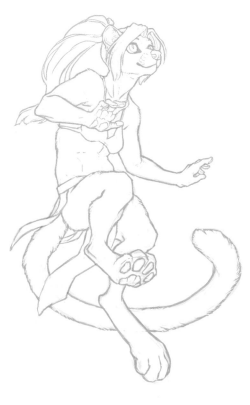

4 **Refine Your Sketch**
Once you've chosen the gesture sketch you want to develop into a character painting and have acquainted yourself with your animal subject by doing studies and/or gathering reference, you're ready to get started. Open your gesture sketch in Photoshop and create a new layer. Set this layer to Multiply. This will allow you to see any layers underneath your sketch. Then take care to refine your sketch into a more detailed and solid figure drawing.

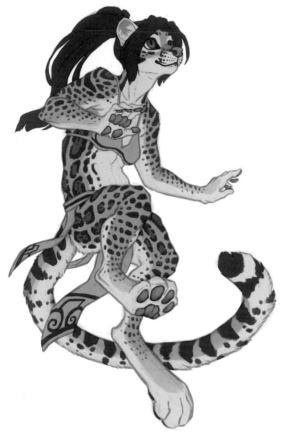

1 Apply Local Color
Before diving headfirst into shading your sketch, think about the local colors. Local color is the color of an object unaffected by lighting. Think of it as the true color of something. Once you add light, the colors of the object change based on the color, angle and intensity of the light source. Then there's the transparency of the lit object, the colors of surrounding objects and other factors. For now, create a layer just for the local color, and make sure it's below your refined sketch layer. Leave it set to Normal because you will not want any special effects for your local colors.

2 Paint Basic Light and Shadow
Now you can start shading! Create a new layer above your sketch layer and set it to Multiply. In addition to letting you see what's underneath, the Multiply setting darkens and combines with the layers below it, allowing you to create shadow and light colors that build upon the local colors. Generally choose cooler, darker colors for the shadows and lighter, warmer colors for the lit areas. A light gray-purple works well here, but experiment to see what you like best. As you are painting, be sure to keep your brushstrokes loose and big—no need to worry about finer details such as fur texture or whiskers just yet.

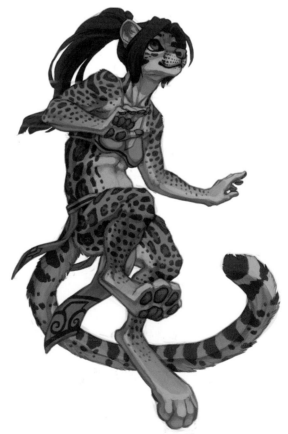

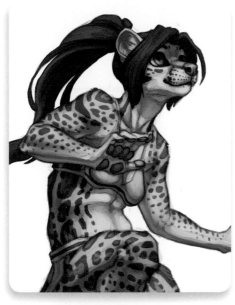

3 Build Up the Form

A good way to make your character appear three-dimensional is to build up lighter colors on top of your basic shading. Create a new layer above your light and shadows layer, and set it to Overlay. Like Multiply, the Overlay setting allows you to see the colors in the layers underneath. As you paint a warm pale yellow color on the surfaces facing the light, it will brighten the underlying color.

4 Final Details

Now that you have all your lighting and colors the way you want them, you can focus on those delicious details! Create a new layer above all your existing layers, and keep it set to Normal. Use the Eyedropper tool to select colors from your painting to use. Now you can refine, add detail and paint in fur texture as you go.

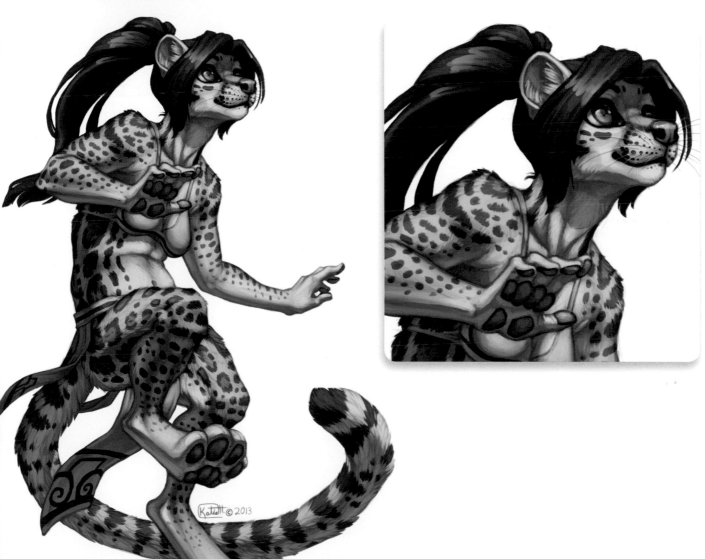

Planning an Illustration

How do you turn an idea into a great illustration? You want to make sure the elements of the illustration are thoughtfully arranged and flow well visually. Loose compositional studies (called thumbnails) will help you work that out. You'll also want to do some visual research and sketching to understand your subject. Once you have the basic structure in place, it's on to drawing and painting. To take you through the process, I'll be illustrating a pair of bats, some of my favorite animals, soaring through the forest in a nighttime scene.

For creating the composition, first let's consider some guidelines for making good compositions. A good composition looks pleasing and helps you tell your story. Here are a couple of things to consider when composing your illustration.

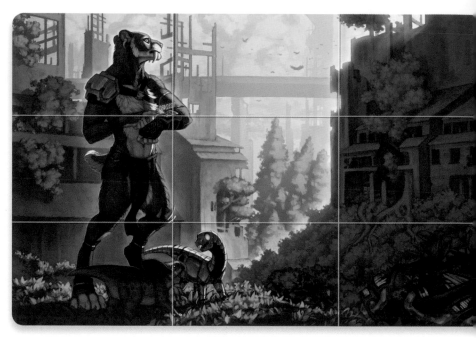

Rule of Thirds

If you divide an image into thirds by drawing vertical and horizontal lines over it, you will get four points at which those lines cross. The rule of thirds is the idea that an image is more interesting when the focal point (where you want the viewer to look the most) lies on those cross points. For instance, the face of your character, which is often a focal point, can be on or near one of those intersections.

Dark and Light

It's important to keep the shapes of elements in your illustration easy to see. Focal points such as your character should stand out against the environment. One good way to do this is to make the values (how dark or light something is) significantly different from each other. A character emerging from a dark scene might have a lighter value than the surrounding environment, or if your character is standing in daylight, you can make it stand out by giving the background a dimmer value.

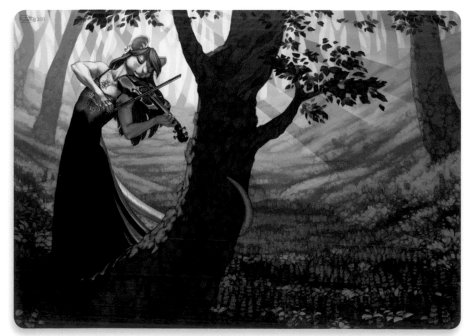

Make Thumbnails

Creating thumbnails is like brainstorming visually, just like gesture sketches. Don't worry if your ideas seem interesting or not; just get them down so you can try different ideas. Sometimes the first idea is the best one, and sometimes it takes making a few thumbnails to get an idea you like.

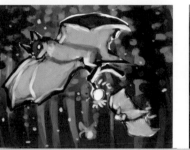
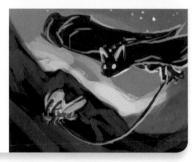
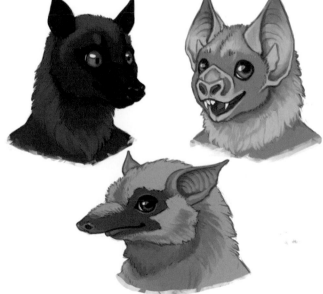

Sketch Studies

You'll want to research the animal you're drawing. Bats have enormous facial variety with lots of shapes and types to choose from! If you want a specific species, it helps to find out their common name when you search for image references. Shown here are Indian flying foxes (left), vampire bats (right) and a proboscis bat (bottom).

Bats: Coloring

1 Refine the Sketch
Once you've chosen your thumbnail and have done some research on your animal, you can start refining your sketch. In Photoshop, create a new layer for your sketch. Set the new layer to Multiply; this will enable layers beneath the sketch (like the colors in the next step) to show through. Use a light gray as your sketch color. While drawing, use visual reference to understand the details of the animal and environment you're drawing.

2 Apply Local Color
Breathe a little life into your scene with color! Create a new layer below your sketch layer and keep the layer properties set to Normal. For now, think only about the local colors of your scene, that is, the colors of an object unaffected by the color of light or surrounding objects. Don't apply any shading yet.

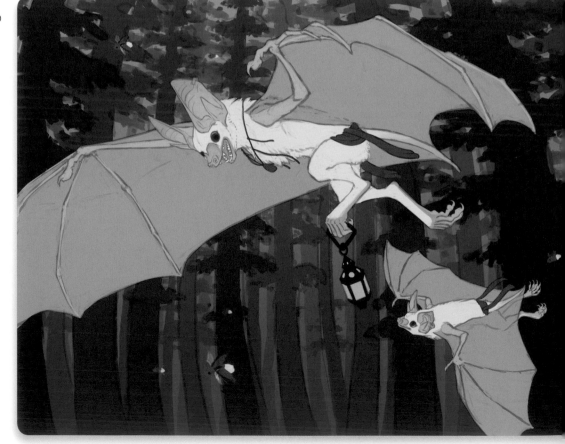

3 Paint Basic Light and Shadow

Create a new layer above your sketch layer and set it to Multiply. This layer is for painting your basic light and shadow colors. For a dark scene like this, it's helpful to start by filling the entire layer with the shadow color. Now think about where your light sources are, in this case, the lantern dangling off the bat's foot, the lightning bugs flittering about and the moon. Consider where the light falls on the scene and characters as well—on the underside of the foreground character and on the face and back of the background character. The color of the light is also important; objects like lanterns emit a warm yellowish orange light, while the light from the stars and the moon of the night sky is a cool blue light.

4 Build Up the Forms

You can build up the forms in your illustration by adding more lighting colors. Create a new layer above the basic light and shadow layer and set it to Overlay. The Overlay setting allows the colors from the layers below to show through, but brightens them so you can create a rounded, three-dimensional look in your painting. Choose a color close to your light color from the previous step. It's still not time for details, so keep your paint strokes broad and loose!

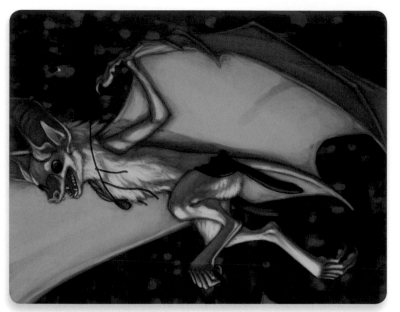

5 Transmitted Light

Light does all sorts of interesting things. You can spend forever studying how it bounces around and affects the colors of the surfaces it touches. Transmitted light is light that shines through certain objects, like leaves or the membrane of a bat's wing. When light transmits through objects, it picks up the color of the object. If your character has light shining through any part of its body that is thin, like an ear, it will pick up a little of the red of the flesh and shine through to the other side.

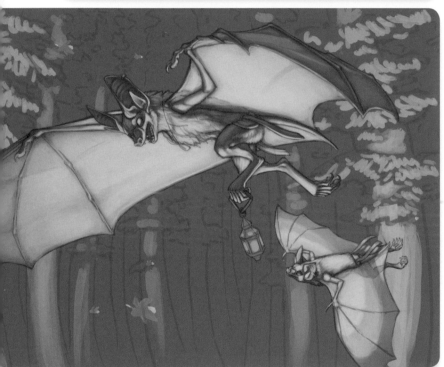

6 Show Your True Colors

Let's take a look at the layers that make up the shading. If you turn off the local color layer, you can see how the layers set to Multiply and Overlay look on their own. This method of painting allows you to think of the color of the light and shadows separately from the local color, rather than attempting to mix them and paint directly.

7 Comparison

The shading layers with (top) and without (bottom) the local color layer.

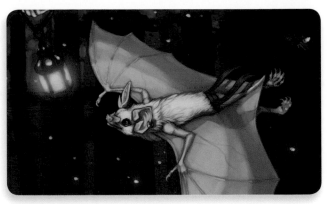

8 *Time for Details*

Finally! With the light and colors in place, now you can focus on details and touching up things. Create a new layer above all of your existing layers and keep it set to Normal. Move through the image and use the Eyedropper tool to choose colors from the areas you are refining, and paint in the details directly over them.

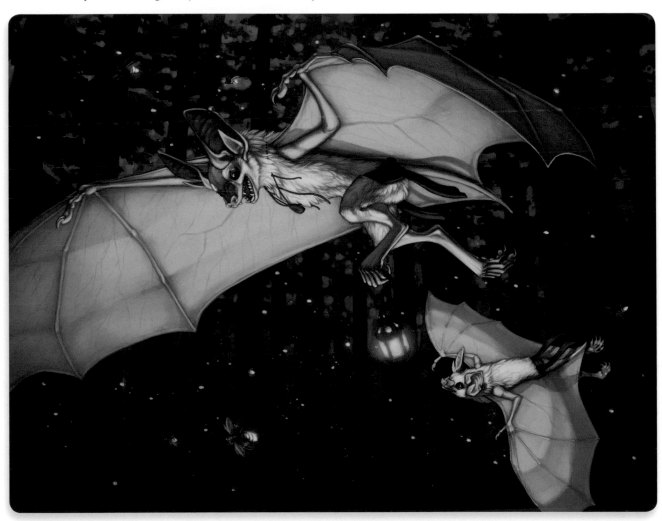

Guiding Light
Photoshop

CHAPTER TWO
RUdragon

RUdragon was born in Honolulu, Hawaii on April 21, 1987. Even from a young age, he's always had a love for creating new things, whether it was making little machines out of common household items or folding origami. But it wasn't until his teens—when his younger sister teased him about some drawings he'd done—that his passion for art ignited and he began to get serious about drawing. Eleven years in and he's still at it, constantly pushing to improve his abilities. He's always trying new things with his art and throughout the years has expanded his repertoire to comics, flash games and animation.

RUdragon enjoys participating in the online art communities, like DeviantArt and Fur Affinity. They are a source of encouragement and inspiration for him, and he tries to give back as much as possible. When he's not drawing at his computer, he's most likely drawing on paper! He hopes to continue making comics and animation to entertain people for a long time.

RU and Mako
PaintTool SAI

Style

Motto: "Everything cute, punk and awesome!"

When I make any piece of art, I like to start with one or more keywords for the theme. For example: cute, cool, punk, cartoony, semirealistic, complex or simple. This helps me focus on the mood and my goals for the picture. Most of the time, I gravitate toward combining cute and punk. I consider that to be my trademark style!

My favorite types of creatures to draw are dragons and sharks, so they show up a lot in my furry art. My two main characters are RUdragon, a cute, lil' pink dragon (he's also my fursona), and Mako, a tough-looking shark who's really a big softie. I also enjoy coming up with and designing new characters, as well as drawing human characters.

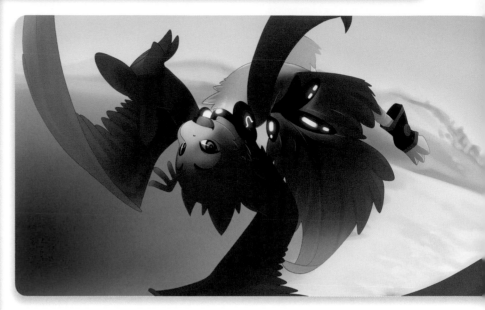

Free Bird
PaintTool SAI

I wanted to capture the breathtaking joy of flight by showing the character spiraling over a brightly colored vista. When working with bird anthros, there are lots of possibilities for creating epic and dynamic poses, thanks to their ability to fly.

Get Inspired!

When making a new picture, it's good to have a plan. When I don't know what to draw, I'll listen to music or look at art for inspiration (not just pictures as a whole, but parts like shapes, camera angles, colors—you can add all the things you like into one awesome-looking picture). Sometimes I'll just sketch, letting my pencil move around the canvas, doodling random heads and poses until an idea comes together.

It also helps to think about what interests you. If you like ninjas, llamas and rainbows, put them all together and try to make something new and cool. I like to sprinkle a little bit of sci-fi and Oriental flavor into my work. The key is to just have fun!

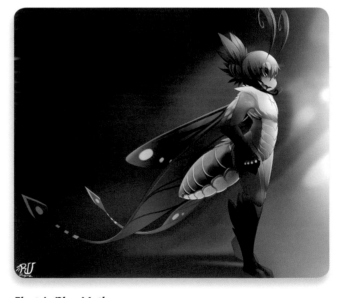

Electric Blue Moth
PaintTool SAI

Being so different from mammals, insects can be a challenge to anthropomorphize. But they can lend themselves to unique characters if you're careful about how you approach the design. My goal for this moth was to create a character that looked both cool and cute.

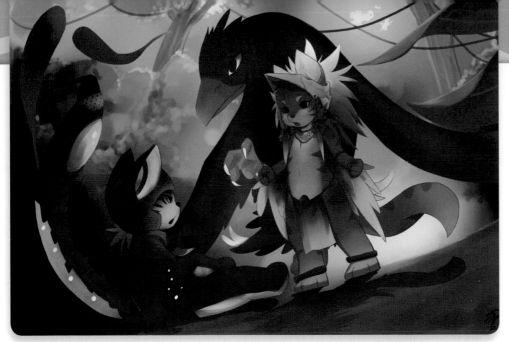

Ah, Who Are You?
PaintTool SAI

To create this larger-scale illustration, I used separate layer sets for the background and all the characters. This helped me work out each element separately. I placed the light source behind the characters to cast them in shadows and add to the drama of the scene.

Fox-Tan KORYO
PaintTool SAI

This image comes from a larger wraparound mock book cover. I've always been interested in *kitsune* (foxes) and Japanese folklore. This little kitsune, Koryo, is on an adventure to earn his nine tails with the help of an orphan girl and a monk-in-training, Tan. I hope to one day tell Koryo's story as a comic.

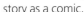

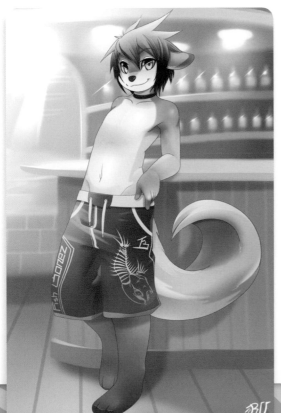

Dood
PaintTool SAI

You can turn a simple character design into much more by including a background for the character to interact with. Here is a dog-otter anthro chilling at a tropical resort. Pairing two animal types is a great way to spark creativity.

Artist's Toolkit

I do most of my drawing and painting entirely on the computer. My main tools of the trade are a Sony VAIO E series laptop, a Wacom Cintiq 12WX (a tablet with a visual display) and PaintTool SAI. Keep in mind that you don't need an expensive computer or a high-end tablet to do digital art. PaintTool SAI is a really lightweight program, so most computers should have no trouble running it.

Materials list

- PaintTool SAI
- Sony VAIO E series laptop
- Wacom Cintiq 12WX
- Washcloth (to rest my hand on when using the Cintiq)

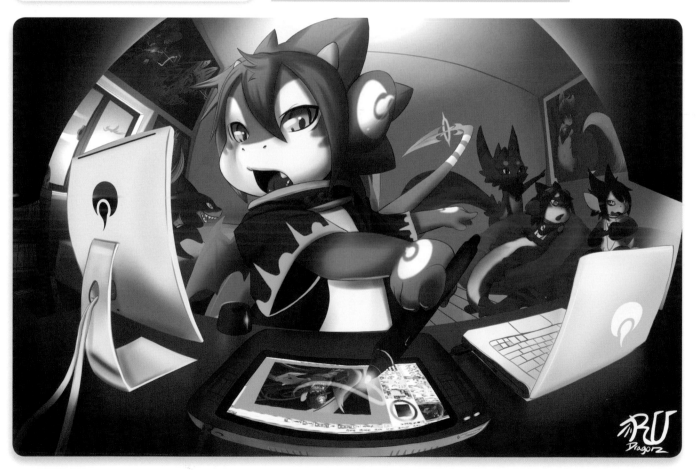

RU at Work

For tips on designing your own fursona like RUdragon visit impact-books.com/furries-furever

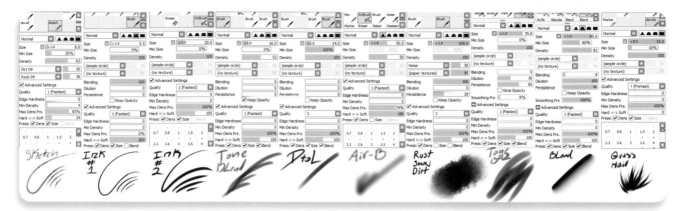

PaintTool SAI Brushes

These are all of the brushes I use for my images. The primary five brushes I use for everything are Sketch, Ink #1 (thin lines), Ink #2 (comic lines), Air-B (AirBrush) and Tone Blend. I use the rest of the brushes occasionally for painting and for textures like snow and dirt. All the settings are shown here, but you may have to substitute textures on some of the brushes.

The Stabilizer setting in PaintTool SAI helps smooth your lines while you draw.

The higher the setting on the scale (it goes from 0 through 15 and the more precise S-1 through S-7), the smoother the lines and the slower the cursor draw speed. For sketching and color blending on my Cintiq, I like to set it at 14, but when I'm using just a standard tablet, I find that a lower setting of 6 works better. It depends on the device you're using, so try adjusting the number to see what feels most comfortable.

Fun Facts

Another term for anthropomorphic animals is *funny animals*. The term predates furries and is used primarily to refer to talking animal characters found in humorous comics and cartoons.

Work Space

Dog: Drawing the Head

Because the head is often the focal point of a character image, it's important to practice drawing it from various angles. Every artist has their own technique for drawing the head, but the most common approach is to break it down into shapes. Here I'll show you, step-by-step, how to draw a cute anthro dog head from various views. Once you get the hang of it, try substituting other ear and muzzle shapes to create other animal types, and experiment with different head angles.

Eventually, as you become more comfortable with drawing, you may find you're able to skip a step and do some of the basic buildup in your head before your pencil even touches the paper. The fastest way to get to that point is lots of practice drawings! So let's get started!

Three-Quarter Front View

1 Start With a Circle
Draw a circle with crosshairs. The vertical line indicates the centerline of the face. Centered beneath the circle, add a tube shape for the neck.

2 Draw the Muzzle and Ears
Sketch a rounded shape extruding from the center point of the face for the muzzle. Add a pair of triangular ears at the back of the head. Align the ear tips.

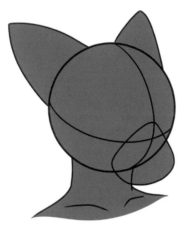

3 Add Facial Features
Along the horizontal line, sketch the eyes, leaving the space of one eye between them. Then draw the eyebrows. Add the nose, mouth and inner ear. Finally, sketch the general position of the hair.

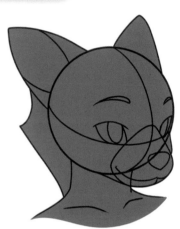

4 Detail and Color
Sketch the hair, leaving room for the ears to poke through. Fluff out the cheek and neck fur. Tighten or ink your lines, then erase any guidelines.

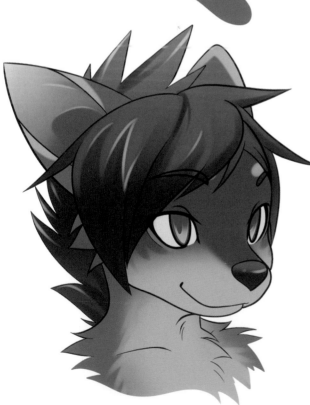

Follow These Steps:

Step 1: Draw a circle with guidelines to indicate the direction the character is facing.

Step 2: Build up the basic shapes including the muzzle, ears and hair.

Step 3: Draw the eyes and other details, and erase your guidelines. Then add color!

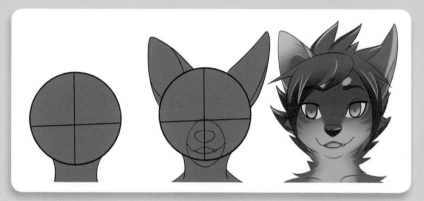

Front View

When viewing the face straight on, the muzzle becomes compressed due to foreshortening. Also, this view is unforgiving if the features don't line up, so pay special attention to spacing. That said, asymmetry isn't always a bad thing. For example, this dog's tilted ear, off-center hair part, and fang create points of interest in the image.

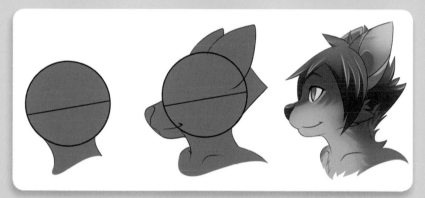

Side View

You may find that a head in profile is easier to draw because you don't have to worry so much about perspective. Instead, focus on the contours of the face, like the curve of the nose, lips and forehead.

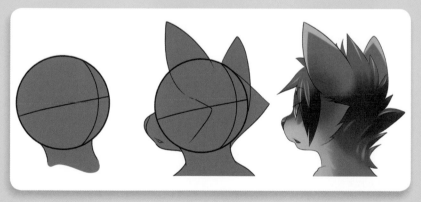

Three-Quarter Back View

Drawing the back of the head can be tricky without a visible starting point to anchor your muzzle. Locate it by following the curvature of the guidelines to where they meet in the front. Note that the muzzle appears shorter from this angle because it is partially obscured. The ears, however, take a front position.

DEMONSTRATION
Dog: Portrait

Once you're comfortable with the basics of drawing the head, try your hand at a bust. A bust depicts the character's head, shoulders and upper chest, enabling you to show more of their personality through body language and fashion flair. I'll show you how to take your character bust from rough sketch to glossy color.

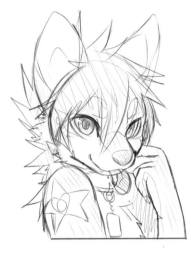

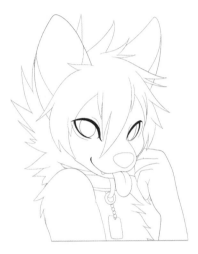

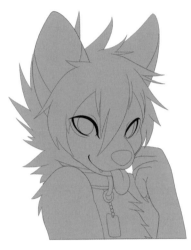

1 Sketch the Character
Do a sketch to work out your character's design and pose. A hand resting on his cheek, an outstretched tongue and a steadfast gaze give this guy a carefree and friendly look. Use rough hatching lines to visualize the areas of light and dark in the image. Don't worry about messiness because you'll be inking the drawing in the next step.

2 Ink Your Drawing
Lower the opacity of your sketch and make a new layer above it for inking. Select the Ink #1 brush tool and set the Stabilizer to S-7. Take your time with your strokes to ensure smooth lines. Keep the lines simple by focusing on the character's contours. Skip details like the tattoo and inner eye. When you're done, click the Preserve Opacity checkbox on the layer panel to protect your inks. Turn off the sketch layer.

3 Prep the Layers
Using the Magic Wand tool, click outside the character to make an area selection. If necessary, fine-tune the selection with the Select tool. When you're done, invert your selection. Then create four new layers. Use the Bucket tool to fill the first layer, Grayscale, with a mid-gray tone. Then fill the second, Flats, with your character's main color and the third, Color Correction, with brown. Fill the fourth layer with blue and set it to Screen at 15% opacity. Check the Preserve Opacity box for all four layers.

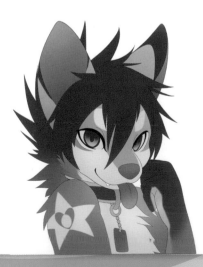

4 Apply Flat Colors
Turn off all layers except your Flats and Inks. On the Flats layer, use the selection tools to fill in the character's local colors. Refer to your sketch layer for guidance on color divisions, like his fur patterns and tattoo. Use the Blur tool to soften edges and the Airbrush tool to create soft gradations of color. When you're done, change the layer mode to Overlay.

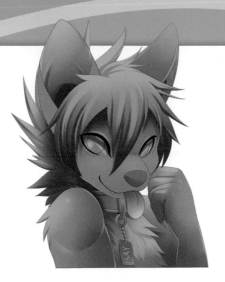 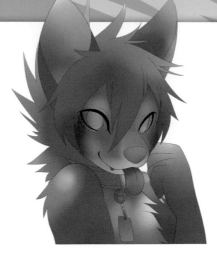 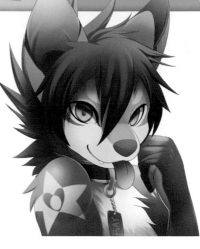

5 *Apply Grayscale Shading*
Switch to the Grayscale layer. Use the Magic Wand to select an area (like his face). Build up the values in grayscale with the Tone Blend brush, taking into consideration where the shadows would fall on the character. Blend and smooth tones with a combination of the Tone Blend and Airbrush. As you complete each area, jump between this step and the next to adjust colors.

6 *Color Correction*
With an area still selected, switch to the Color Correction layer and set it to Overlay. The colors will look a bit grayish at this point, so the goal is to vivify them using this layer. Pick a color close to the base tone and apply it loosely with the Airbrush; duller shades tend to work better. I used purple for shadows and orange and yellow for the lit areas.

7 *Put It All Together*
Turn on all four layers and evaluate the image. If the colors look too intense, you can subdue them by slightly turning up the Opacity of the blue layer (be careful not to set it too high or your picture will turn blue).

8 *Finish and Add Highlights*
Make a new layer above the line art. Use the Ink #1 brush with the Stabilizer set at 14 to add sharp highlights to the eyes, nose, tongue and hair to give them a glossy finish.

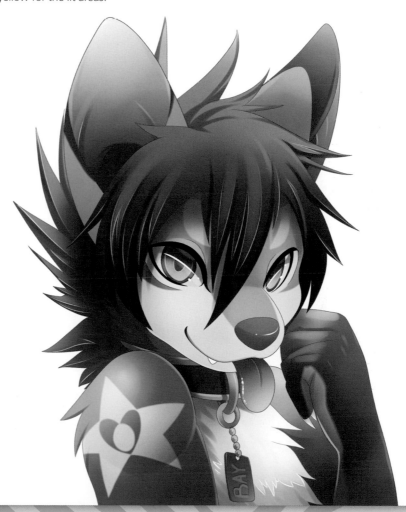
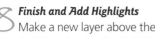

Lil' Dragon

RU is a cute, pink lil' dragon. He may be small, but he's not a kid. This dragon species only grows to about 3'5" (104cm) tall at full maturity. But, with a little twist of the tail, he can stand eye-to-eye with any of his furry friends. In this section, I'll show you how to draw and color your own RU-style lil' dragon in PaintTool SAI.

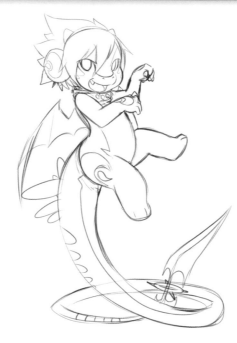

1 Sketch the Character
RU stands about three heads high. Heads high is an artist's measurement of a character's head size in relation to the rest of its body—an average adult human is about seven heads. RU's large head and compact body give him a huge boost of cuteness, as do the playful pose and open-mouthed smile. Keep proportions in mind as you sketch your own lil' dragon.

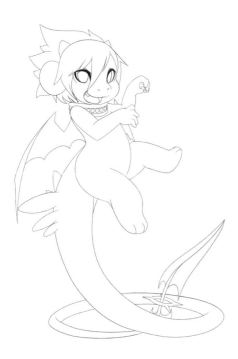

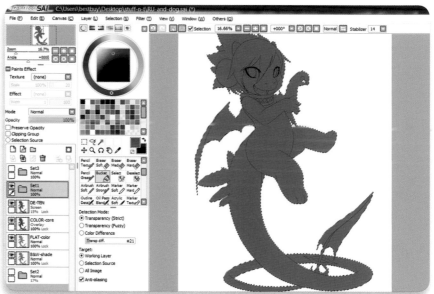

2 Ink Your Drawing
Make a new layer above your sketch for inking (you'll want to lower the opacity of your sketch layer so you can see what you're doing). Using the Ink #1 brush tool with the Stabilizer set to S-7, carefully follow the sketch, taking care to draw smooth and even lines. Leave out any extraneous details; areas like RU's body markings will be depicted with color alone.

3 Prep the Layers
With the Magic Wand tool, make a selection around the outside of the character. Then go to Selection on the menu bar and choose Invert. This will change the selection to cover your character. Next, create four new layers beneath the inks. Use the Bucket tool to fill the first layer, B&W-shade, with a mid-gray tone. Fill the second layer, FLAT-color, with the main color of your character. Fill the third layer, COLOR-core, and set it to Overlay. Finally, fill the fourth layer, DE-TEN, and set it to Screen at 15% opacity. When you're finished, check the Preserve Opacity box on all four layers.

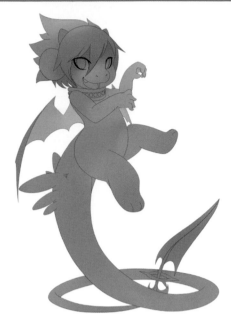

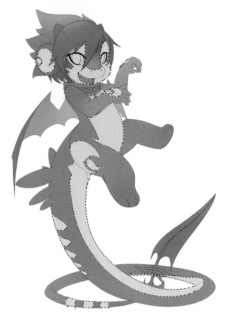

4 Color Variation
On the FLAT-color layer, use the Airbrush tool to add some variation to the character's colors. I applied several shades of pink and purple to RU from tail tip to hair. This helps the character look soft and rounded.

5 Body Markings
Next, turn on your sketch layer and use the Select tool to circumscribe the character's body markings. Then fill them with a light pink. When you're finished, turn off the sketch layer again.

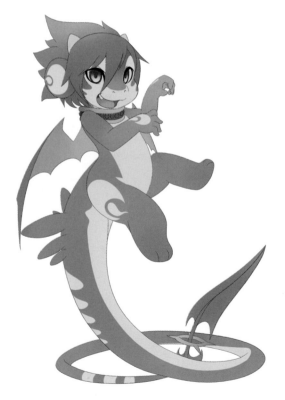

6 Soften the Edges
Use the Blur tool to soften the edges of the markings.

7 Apply FLAT-Colors
Repeat the process for the eyes and other areas. Then change the FLAT-color layer's mode from Normal to Overlay.

8 Apply Grayscale Shading

On the B&W-shade layer, use the Magic Wand to select several non-touching areas (for example: his tail, left leg, face and back section of hair), and begin shading in gray tones with the Tone Blend brush. Try to express the volume of his form using darks and lights. Use the Tone Blend and Airbrush tools to smooth the transition between tones. As you complete each area, jump between this step and the next one so you can continue to make use of your selection, adjusting colors as necessary. When you're finished with the first set, invert your selection to shade the rest.

9 Color Correction

Switch to the COLOR-core layer. The grayscale shading gives the colors a grayish tone, so now you're going to use this layer to brighten them up! Pick a color close to the base tones and apply with the Airbrush tool. Avoid using overly bright colors, duller shades tend to work better. Here I've used a rusty orange for the highlights and a muted purple for the shaded areas.

 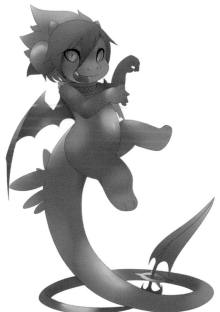

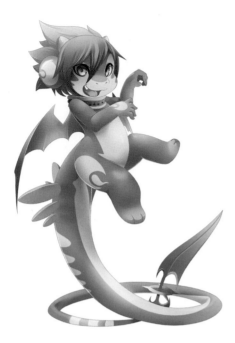

10 Put It All Together

Turn on all four layers and evaluate the image. If necessary, you can reduce the intensity of the colors by slightly increasing the Opacity of the DE-TEN layer. Otherwise, it's ready for finishing touches!

Make a new layer above the line art and use the Ink #1 brush with the Stabilizer set at 14 to add sharp highlights to any parts needing a little bit of extra shine. As one final touch, you can soften your image by changing the color of the lines. To do so, first check Preserve Opacity on the Inks layer to protect your lines. Then simply fill the Inks layer with a color that matches the overall tone of the image. I used purple here.

RU and Tiger (2013)
PaintTool SAI

If you want, give your dragon a furry friend to hang out with. Then let your imagination go wild and paint a background. Layer brisk brushstrokes in shades of green to create a grassy field, and then add some water, sky and clouds. Blend out the colors where necessary and brush in details to fill out the scene.

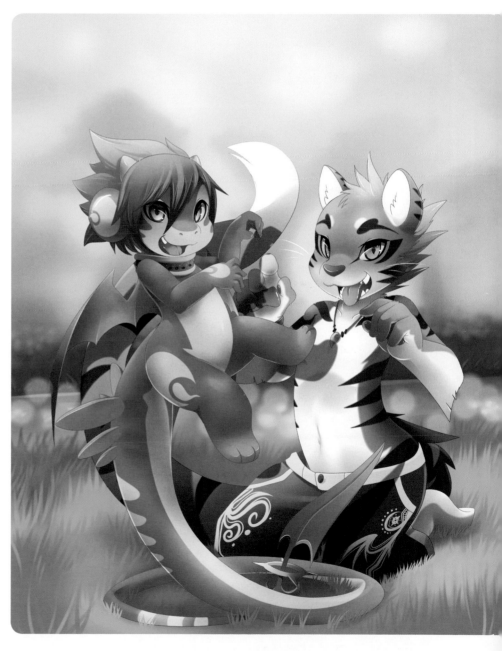

CHAPTER THREE
Lindsay Cibos

Lindsay Cibos is a graphic novelist and illustrator who has been residing in sunny central Florida since she was born. Best known for the graphic novel series *Peach Fuzz*, Lindsay has also co-authored several art tutorial books including *Draw Furries* and *Draw More Furries*, as well as given art advice in *ImagineFX* magazine. She has worked as a penciler for comic publishers including Archie Comics (*Sabrina the Teenage Witch*, *Sonic the Hedgehog*) and Archaia Entertainment (*Fraggle Rock*). When she's not drawing comic pages or sketching animals, Lindsay enjoys watching animation, reading comics and playing video games. She's currently working on a full-color graphic novel, *The Last of the Polar Bears*.

Snow Bear
Pencil and Photoshop CS3

Style

I strive to create art that is cute, fun and expressive. Growing up, I enjoyed both painting realistic renditions of animals and drawing my favorite cartoon characters. Over time, these opposing art threads have merged into a style that's semi-cartoony with a touch of realism. Maybe it's from years of making comics, but when I'm drawing, I'm almost always thinking, *story*. Storytelling elements and emotive characters are the heart of my illustrations. To convey that all-important sense of warmth in my art, I tend toward light pencil lines with soft-shaded coloring.

More than any other artistic medium, animation has had the biggest impact on me, especially the films from the Walt Disney Animation Studios and Studio Ghibli. Comics and manga have largely influenced my artistic style as well. Animation director Hayao Miyazaki and cartoonist Osamu Tezuka, both master storytellers in their respective mediums, are my artistic heroes. I also find inspiration in nature, animals and children's illustration.

Fancy Friends
Pencil and Photoshop CS3

Use props to expand your pose options by giving the character something to do with its hands. Props also offer clues to an illustration's story. For example, in this image, even without a background to set the scene, we can surmise from the rhinoceros's umbrella that these ladies are outside for a stroll, while the fennec fox's use of a fan to coyly veil her mouth suggests the sharing of juicy gossip.

Koala Cutie
Pencil and Photoshop CS3

To heighten the cozy factor of this koala girl portrait, I used soft pastel colors and focused on keeping the shape of her nose, cheeks, ears and neck ruff simple and rounded. I blended some pinks around her eyes and nose to give the effect of skin showing through the short, white patches of fluff, a detail typical with real koalas. As for adornments, a single blue bow, matching the color of her nose, provides a nice accent.

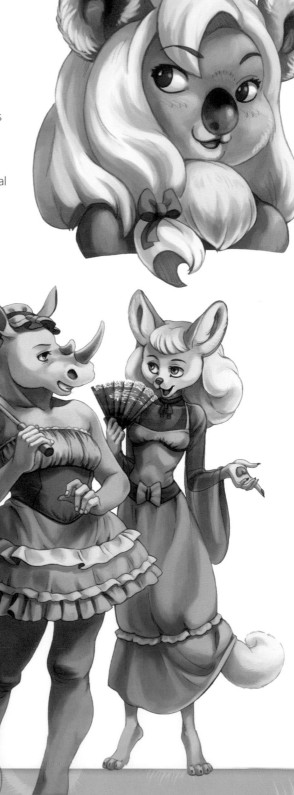

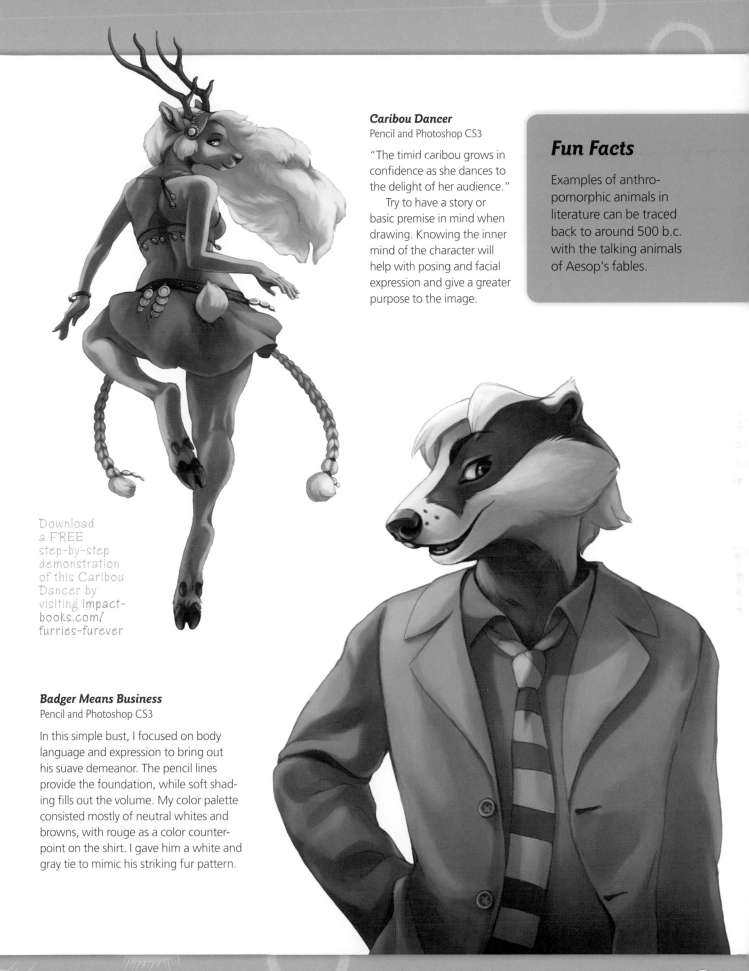

Caribou Dancer
Pencil and Photoshop CS3

"The timid caribou grows in confidence as she dances to the delight of her audience."

Try to have a story or basic premise in mind when drawing. Knowing the inner mind of the character will help with posing and facial expression and give a greater purpose to the image.

Fun Facts

Examples of anthropomorphic animals in literature can be traced back to around 500 b.c. with the talking animals of Aesop's fables.

Download a FREE step-by-step demonstration of this Caribou Dancer by visiting impact-books.com/furries-furever

Badger Means Business
Pencil and Photoshop CS3

In this simple bust, I focused on body language and expression to bring out his suave demeanor. The pencil lines provide the foundation, while soft shading fills out the volume. My color palette consisted mostly of neutral whites and browns, with rouge as a color counterpoint on the shirt. I gave him a white and gray tie to mimic his striking fur pattern.

Artist's Toolkit

I consider myself primarily a digital artist, producing all my finished color art in Photoshop CS3. However, I still do the drawings traditionally using pencil on paper because I find it gives me a greater degree of control and precision. I usually draw with mechanical pencils, but for looser experimental sketches in my sketchbook, I'll sometimes use blue line pencil finished with 2B pencils.

My artistic process starts with a series of thumbnails. Once I settle on a composition that best captures the heart of the idea, I recreate it at a larger size. I usually take this draft all the way through to completion, but sometimes I'll transfer the drawing onto a new sheet of paper and use a light box to clean up any rough lines or make substantial revisions. When the drawing is complete, I scan it into Photoshop. From there, I paint the base colors, adding shading and details to express volume and mood until the picture is complete!

Tip: Start Simple

You don't need much to get started. The most important things are a pencil, eraser, some paper and the enthusiasm to draw. There are no wrong or right tools for expressing creativity. I recommend starting with the supplies you have readily available around the house, then expanding your stock as desired or as necessity demands.

Materials list

Assorted Supplies

- Assorted erasers and rulers
- Circle and ellipse guides
- French curve
- Paper: General paper for sketching, quality drawing paper for finished drawings
- Rulers and Guides
- T-square for drawing horizontal and vertical lines

Miscellaneous

- Anatomy charts
- Art and photo books for reference and inspiration
- Figurines for three-dimensional reference
- Lightbox for transferring drawings, creating overlays and checking for mistakes
- Mirror for facial expression and hand reference
- Sketchbook
- Thumbtack board for pinning up notes, reference and inspiration

Digital Tools

- 11" × 17" (28cm × 43cm) flatbed scanner
- Adobe Photoshop CS3
- Computer with good speed and storage capacity
- Wacom graphics tablet

Drawing Supplies

Adobe Photoshop CS3

Work Space

My drawing work space consists of a drafting table with an adjustable desk lamp and all of my pencils, erasers and other art supplies within easy reach. Also, a mirror for posing reference, a laptop with my music and reference photos and a board for pinning inspiration. I have a second work space set up for digital coloring, it consists of a desktop computer and Wacom tablet. An ergonomic chair with good back support is also a must for long hours making art.

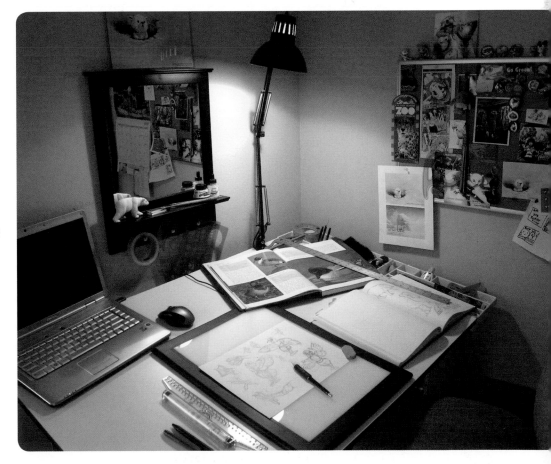

Harp Seal

Baby harp seals melt hearts with their large, inky black eyes, roly-poly bodies and fluffy fur, making them a fantastic candidate when you're in the mood to create an irresistibly cute anthropomorphic character.

The pinniped's fin-footed, streamlined body is built for maneuvering water with grace, but it presents the furry artist with a challenge. How to anthropomorphize the seal's unique anatomy?

One possibility is to depict your seal character with human legs and flipper feet. Another option is the mermaid route, in which the character has a lower flipper body in lieu of legs. Either choice has its benefits: legs give the character mobility and flexibility with its fashion choices, while the mermaid tail lets it retain the streamlined seal look. The seal anthro shown here demonstrates the latter approach.

1 *Brainstorm Character Designs*
Start by doing exploratory sketches to work out the harp seal's design and pose. Work at a thumbnail size (no bigger than a few inches) to quickly jot down ideas without getting caught up in the details.

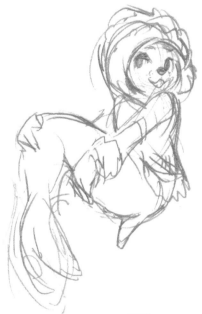

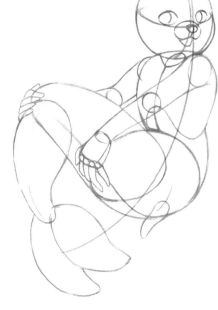

2 *Sketch the Body Position*
Using your thumbnail sketch as a guide, draw a curving line that captures the action of the pose. Sketching lightly, use basic shapes to build the form of the body along this curve. Draw a line down the center of her head, chest and underside of her lower body to indicate their orientation.

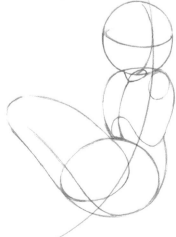

3 *Build Up the Shapes*
Sketch a ball-shaped muzzle at the center point of the head and position her eyes on either side of it, along the horizontal line. Build the head shape up further by puffing out her cute cheeks. Using basic shapes, draw her arms outstretched toward her lower body. From the bend in the "knees," add a gently curving mermaid tail that ends in a pair of flippers. Seals have a stubby tail extending from the base of the spine. I positioned the tail on her rump, where the spine ends on humans, but you may prefer to keep it between the flipper feet as it would be on a seal or omit it altogether.

4 Sketch the Clothing

Draw the basic lines of her outfit without details. To keep her warm in the chilly Arctic, she's wearing a thick fur parka (synthetic, of course), so leave some space between her body and the outfit lines. As you sketch, think about the coat as a three-dimensional object that wraps around her body, and keep in mind the effects of gravity, especially on hanging parts like the sleeves. Finally, carefully frame her face with the parka's fur trim so her cheek overlaps it.

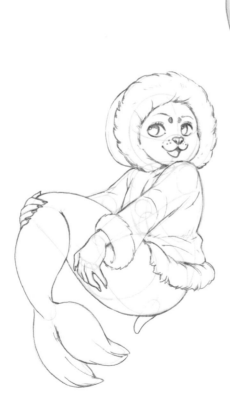

5 Add Details

Fill in her expressive eyes and bring attention to them with dark, feathered lashes. Complete the face with a pair of eyebrows and the seal's signature brow spots. Detail the nose and surround it with a few rows of whisker spots. Use broken lines to express the soft texture of her fur coat. Add claws to her fingertips and divide her flippers into toes. Tighten up the rest of your lines and erase any guidelines.

6 Finish With Color

Use creamy tones with gray-blue shadows to color the fur of a harp seal pup. Fill in the eyelids, brows, nose, lips and whiskers with black to bring attention to her face. I colored the eyes steel blue for contrast. To express the texture of the parka's fuzzy trim, start with dark browns and gradually build up to lighter tones, while keeping in mind the direction of the fur.

DEMONSTRATION
Sphinx: Drawing

The Sphinx, best known from the famous Egyptian monument in Giza, is also a character in Greek mythology. The Greek Sphinx is described as having the body of a lion, the wings of a bird and the face of a woman. She would challenge travelers to solve her riddles, and those who failed were mercilessly devoured! However, other legends characterize the sphinx as being a benevolent protector.

For this character, we'll create an anthropomorphic sphinx dressed in Egyptian-inspired clothing, a fusion of her Greek and Egyptian roots. With a sharp tongue and a fondness for riddles, she sits atop a pedestal on the lookout for travelers to quiz (for her amusement, not dinner).

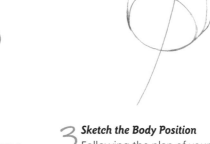

1 Brainstorm Character Designs
Do some rough sketches to figure out your character's look. Consider the character's personality. This sphinx is a catty snob who's used to getting her way. Reflect these traits in her facial expression and body language. For her costume, browse images of ancient Egyptian art and classic interpretations of the sphinx for inspiration.

2 Thumbnail Pose
Working small, no larger than a few inches, decide on a pose and do a final take of the design that combines all of your favorite elements from your exploratory sketches. Although rough and lacking detail, this sketch should give you a strong idea of what the finished picture will look like. Think of it as your road map.

3 Sketch the Body Position
Following the plan of your thumbnail, start with a circle for the head. Add a centerline to establish facing. Sketch a curving line of action and build the rest of her torso along this line. As you draw, keep in mind landmarks like the rib cage, waistline and hips to help with the proportions.

4 Build Up the Shapes

Sketch the eyes, ears, cheeks and structure of the muzzle to complete the basic head shape. Add arms and legs to build upon the solid structure of the torso. Note in the thumbnail how she's pressing against her fingers and toes to hold her position; try to capture that force in the drawing. Then sketch the tail using surface lines to help visualize the curvature.

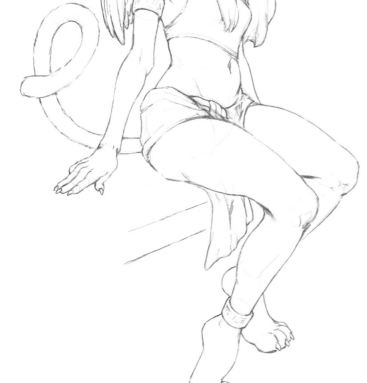

5 Sketch the Clothing

Following the form of the body, lightly sketch the general contours of her outfit. Keep the details minimal for now and focus on flow and curvature. Note how the arm and leg bands wrap around her; draw the full three-dimensional shape to ensure a perfect fit. Sketch her long hair cascading around her ears and behind her shoulders. Finally, build the basic structure of the visible wing (the left is hidden behind her hair).

6 Add Details

Work through your drawing, clarifying lines and adding details. Try for a good balance of straights and curves in the line work (for example, the sharp elbow of the right arm versus the rounded shoulder) to create tension. Draw the toes and add claws (fingers too), fluff up the tail with dashed lines for a hint of fur and draw some folds where the clothing is compressed or pulled. Finally, refine the details of her face, hair and wing. Erase your guidelines.

Fun Facts

Furry art was a part of ancient Egyptian history in the form of animalistic deities like the jackal-headed Anubis and falcon-headed Horus.

Sphinx: Coloring

With the line art complete, the sphinx is ready for color. If you look at ancient Egyptian art, you see a lot of richness and warmth: reds, browns and yellows. Black, white and vivid blues and greens fill out the rest of the spectrum. For our anthro sphinx, I'm using a tawny red color to express her lioness fur; tan for the wings and outfit, and red, blue and gold as accent colors for her jewelry and accessories. Indigo stands in for black hair. But before you can start laying down the colors, you'll need to prep your drawing for digital painting.

If you draw traditionally with pencil and paper like me, the next step is to scan your drawing. Once scanned, open it in Photoshop and clean up the drawing. Use the Eye Dropper tool in a dingy area of the paper as the sample color for adjustment. Then you'll need to adjust the Fuzziness and Lightness sliders; I set it around 70 Fuzziness and +100 Lightness, but it depends on how rough the drawing is and the paper type, so experiment to see what works best. Use the Eraser tool to remove any remaining grain or straight lines, and set the line art layer to Multiply.

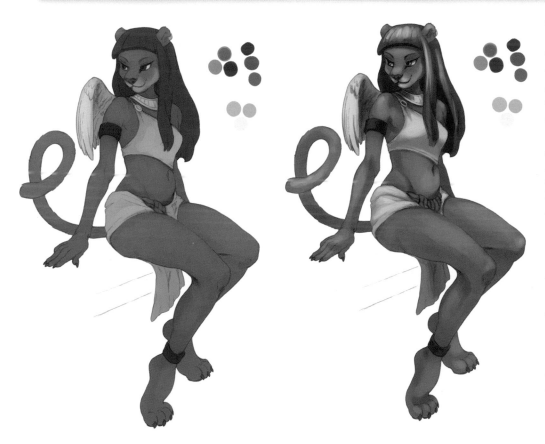

1 Establish the Color Palette
Make a new layer beneath the line art, then use the Lasso tool to make a wide selection around the character and fill it with a neutral color. Carefully erase any colors outside the lines and lock the layer. Make another layer for your palette and dab some colors to set up your color scheme. I'm working with a palette of red, brown, tan and gold, accented with blue and deep purple. Using broad brushstrokes, roughly apply the colors to the character.

2 Block in Shadows and Highlights
Develop the form of the character by building up the shadow tones and highlight areas. Don't worry about getting the shading perfect just yet. The goal at this stage is to feel out your color scheme and lighting.

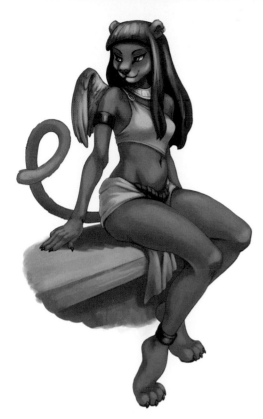

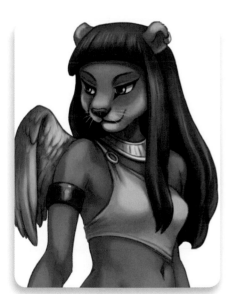

3 Adjust the Shadow Placement

Continue to refine your shading and use a reference photo for help. Brighten up the face to help make it the focal point. On a new layer beneath the character colors, began to paint the pedestal, including cast shadows, to ground the character.

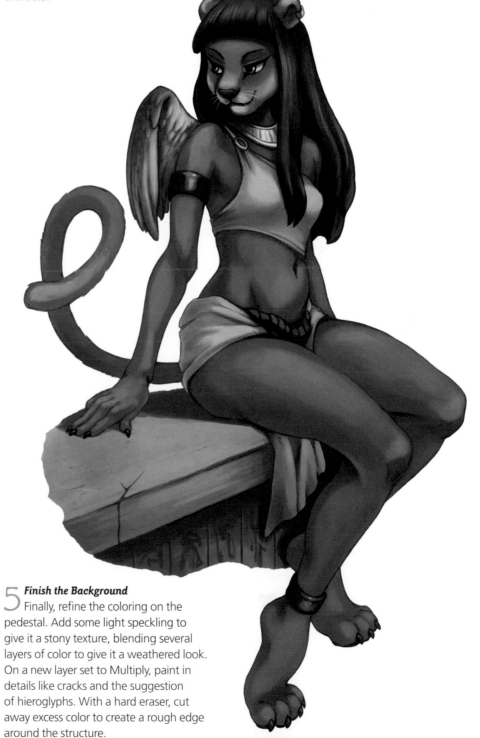

4 Refine the Details

With controlled vertical strokes, build up the shadows and highlights on the hair. Try to keep the shading subtle so the hair doesn't look too stringy. It's a good idea to flip your image periodically to check for mistakes. If you discover you need to fix something about the drawing at this stage, the easiest way is to make a new layer and paint over the lines.

5 Finish the Background

Finally, refine the coloring on the pedestal. Add some light speckling to give it a stony texture, blending several layers of color to give it a weathered look. On a new layer set to Multiply, paint in details like cracks and the suggestion of hieroglyphs. With a hard eraser, cut away excess color to create a rough edge around the structure.

DEMONSTRATION

Sphinx: Hands and Feet

There are numerous ways to approach hands and feet on your anthropomorphic characters. You can draw them like a human's, adding fur coloration and claws, or you can go more animalistic with fully detailed paws and feet. It depends on the sort of character you wish to create. I'll show you a common hybrid style for feline hands and feet. We'll use a lion as our source of inspiration for color, shape and features. Adjust accordingly based on the animal you're drawing.

Hands—This kind of hand is useful for anthro characters because it combines the functionality and familiar shape of the human hand with animal qualities like claws and pads.

 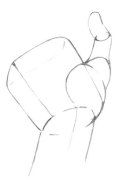 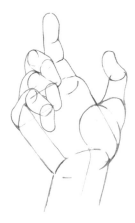

1 Sketch the Basic Shape
A hand can be a complicated body part to draw, so it helps to break it down to manageable, simple shapes. Sketch a rounded rectangle and connect it to a tube for the wrist.

2 Add a Thumb
Building up from the rectangle, sketch an oblong base and add two jointed, cylindrical segments to create the basic thumb shape.

3 Add the Fingers
Sketch the remaining four digits as simple tube shapes. Make sure each has three segments for the joints.

4 Add the Details
Sketch creases in the skin where the fingers bend and the hand compresses. Add thick pads on the fingertips and the center of the palm. Then draw sharp claws embedded in each of the fingers. Refine your lines and erase any guidelines. If you like, apply some light pencil shading or hatching lines for texture.

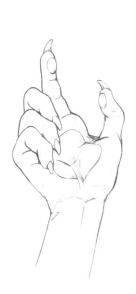 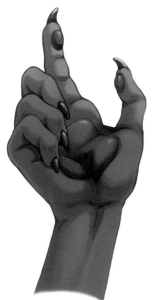

Tip

Need a model for accurate segment length? Take a look at your fingers. The reference is quite literally on hand.

5 Finish With Color
Use a tawny brown for the fur and purple as a colorful substitute for black on the pads. Add shading to suggest volume and texture. Reserve the bright highlights for shiny areas like claw tips.

Feet—Here's an example of a digitigrade-style feline foot, very similar to its animal counterpart, in which the character stands or walks on its toes.

1 Sketch the Basic Shape
Sketch the foot as a simple rectangle. Round and lift the far end to form the heel. Then draw a smaller box at the front of the rectangle for the ball of the foot.

2 Sketch the Toes
Draw a curved oval shape at the front of the foot. Divide the shape into four toes; start with a curved line through the center to create two equal segments. Then draw a curved line through the center of each segment to make four.

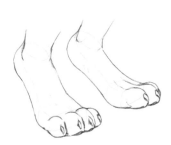

3 Add the Details
Add a curved claw embedded in the center of each toe. You can also show a sliver of padding beneath the toes. Don't forget to draw the anklebone. Refine the line art and erase any guidelines. Use light pencil hatching for a hint of fur texture.

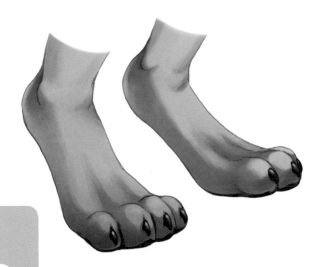

Tip: Cat Paws

Domestic Cat Paw **Lion Paw**

Dancing Bear

In both lions and domestic cats, the front paws have five digits (four fingers and a thumb) plus a carpal pad. The back feet have four digits. Both front and back come equipped with retractable claws.

If you find the paw pad shape confusing, try turning it upside down and picturing a dancing teddy bear.

4 Finish With Color
Add shading around the base and sides of the foot to bring out the volume of the shape. Use a darker color for the pads and claws. Make the claws shine with a small, dashed-on highlight, and your feline is ready to walk.

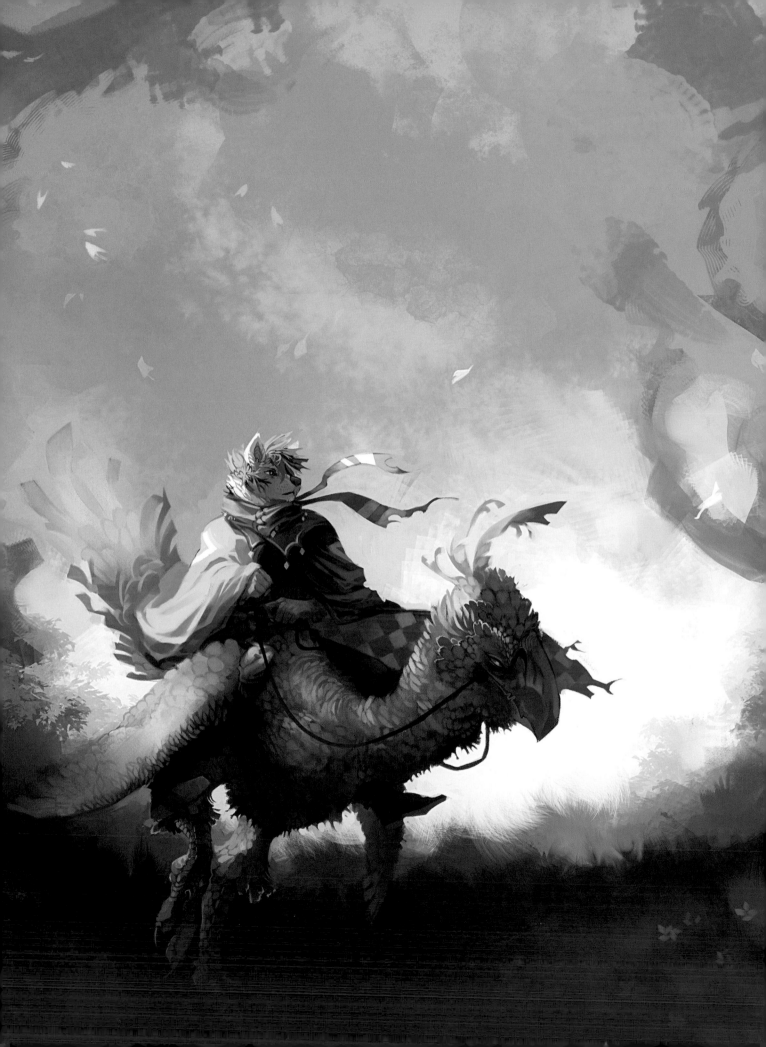

CHAPTER FOUR
Kristen Plescow

Kristen (also known by her online handle, Centradragon) likes Internet memes and is an illustrator currently living in Virginia.

She started drawing as a child, influenced by her travels as a Navy brat and inspired by the world around her. This interest in art continued throughout her middle and high school years. Partially because she failed an AP art exam, Kristen didn't want to be an artist full-time, so she turned to other passions as a potential career choice. She kept drawing but assumed art would remain a hobby.

She entered community college expecting to major in geology—that is, until she took a course in design during her last semester. Three, long years later, Kristen received her BFA in graphic design from Virginia Commonwealth University. A few months after graduating, she started at StarCityGames.com as a graphic designer, which eventually blossomed into a full-time illustration job. As it turns out, art has been a winding road, through different styles and interests, failures and successes. The setbacks only emboldened Kristen to draw as much as possible, and her other interests have served to enrich her art.

Kristen has been involved in the furry community for about five years now and hopes to continue to chat and work with the fandom for years to come.

Sojourner (2012)
Digital

Style

A good way to think of style is like an artistic habit. I tend to use heavy, bright colors and pronounced brushstrokes. I don't like doing thin, dainty line art. I avoid gradients and other overly digital techniques.

I find that being inspired is the easy part, but keeping up that interest is a little harder. I try to introduce myself to as many new stimuli as possible—I go on hikes, travel every once in a while, browse Tumblr feeds before bed, etc. I have a guilty pleasure for video games and particularly enjoy the way they combine artwork with music, story and all sorts of other good things. Photo and picture books are another guilty pleasure, a wonderful way to find references or just escape when you're feeling lazy.

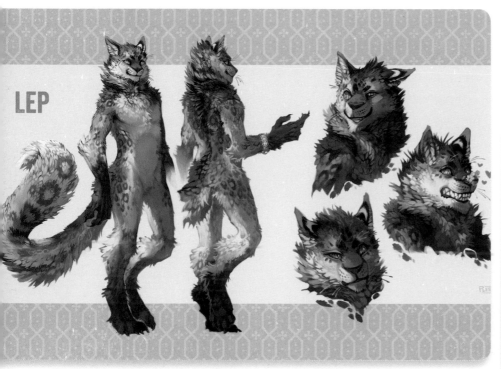

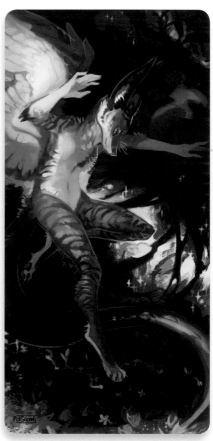

Ajna (2013)
Digital

Because this character lives in a blue-dominated world, I added a nebula-ish patch of warmer colors in the sky as a complement.

Lep Reference Sheet (2013)
Digital

The purpose of a reference sheet is to show a character's design (in this case a fox/snow leopard named Lep) from different angles and/or with various facial expressions. I like having an uneven number of objects on the page to make the composition more interesting. To place the focus on the character, I kept the background simple, utilizing texture and repeating elements.

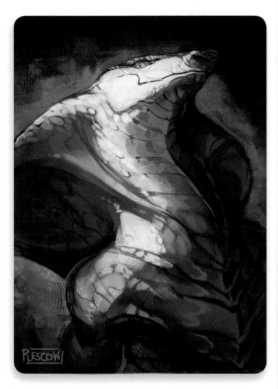

Raja (2013)
Digital, A4

Spotlighting is great for dramatic portraits and shiny scales. To create this piece in roughly an hour from start to finish, I focused on blocking in bold areas of colors with large, textured brushstrokes.

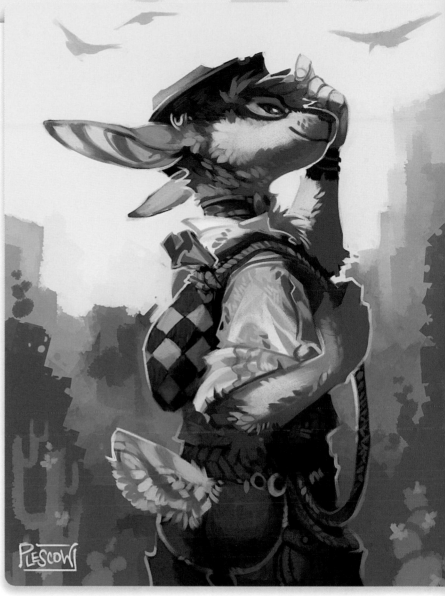

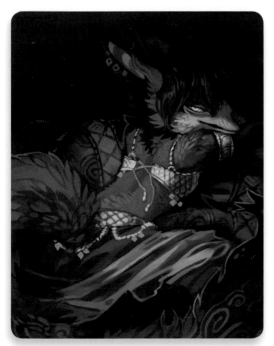

SunnyHoney (2013)
Digital

Backgrounds don't always need details. Just a hint of the West and a few monochrome cacti in silhouette are enough to give this cowboy bunny's pose and personality a little more pizzazz.

Halcyon (2013)
Digital, A4

I used aqua blue-green for her harem outfit with gold accents. I find that blue and gold go well together, and the reddish-brown fur and backdrop adds warmth.

Artist's Toolkit

For my digital work, I primarily use Adobe Creative Suite CC and a 9" × 12" (23cm × 30cm) Intuos 3. All my brushes are custom created (my main one being a standard square brush with a texture). Although my digital work habits are set in stone, I enjoy experimenting with different traditional mediums and surfaces. Having a variety of mediums at your disposal is a great escape from monotony, and many of them are relatively inexpensive to start in.

Fun Facts

In Japan, the term for anthropomorphic animals is *kemono*, meaning beast.

Digital Work Space

This is my main work area, complete with a 27" (69cm) iMac, three printers (all wide format) and a file cabinet that contains printer ink and other necessities. I have a second monitor, and a third 27" (69cm) monitor is on the way. Multiple monitors make it easier to have references or inspirational images up without losing space for drawing.

Materials list

Digital Tools
- 27" (69cm) iMac with 3.4 GHz i7 processor and 8GB of RAM
- Adobe Creative Suite CC
- ASUS Eee Slate
- Intuos3 Tablet

Traditional Tools
- 76-ish Copic markers and refills
- Copic airbrush set
- Golden Open Acrylics
- Holbein Artists' Gouache set
- Illustration board
- Lyra Rembrandt Polycolor art pencils
- Oil paints
- Paper trimming supplies — I highly recommend having a no. 11 X-ACTO knife (replace blades after a couple uses—a nicked blade is more likely to snag or slice your hand), a rotary/straight cutter, a large cutting mat and a steel cork-backed ruler
- Sakura Koi traveling watercolor set
- Sketchbooks
- The basics: mechanical pencils, vinyl erasers, ballpoint pens

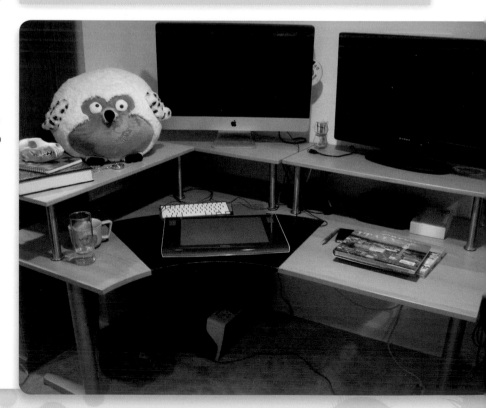

Traditional Work Space

My traditional work area is a simple drafting table. To the side are my paper drawers: inkjet paper on the left, drawing/printmaking paper on the right. I keep other useful tools and Copic marker refills on top. I use the drafting table mostly for larger paintings and drawings that are too cumbersome to work on at my other desk.

Painting Scales and Fur

How you render scales depends on the reference and effect you're going for. If you have a particular creature in mind, study the characteristics of its scales. Tight-knit scales may lack individual definition and appear more smooth or flat, whereas prominent scales that are large, raised or jagged may have individual highlights and cast shadows on overlapping scales. Sometimes you can see underlying skin between the scales, which can shine in different ways independent of any scales on top.

Even when you're painting something fantastical, like a dragon, it's helpful to have a point of reference for inspiration. One of my favorite reptiles to reference are iguanas. They have a huge variety of scales and lots of color and pattern variation.

DEMONSTRATION
Scales

1 *Apply the Base Tone*
Start by painting a base color over the section of the creature where you want to add scales.

2 *Develop Texture*
Apply any color patterns your character has at this stage, and then add some simple color variations or texture for visual interest. You can use a smooth blended approach or keep your brushstrokes rough and organic like mine.

3 *Draw the Pattern*
Add a simple scale pattern outline on top of the base color.

Scale Shapes

Scales come in a variety of different shapes, sizes and arrangements. Study nature (snakes, lizards, crocodiles, etc.) for more ideas, or make up your own patterns.

4 *Add Highlights and Edging*
Using a brighter color applied opaquely, paint highlights between the grooves and ridges of the scales. Consider the shape of the scales and whether they are flat or raised. In this case, with the scales lit from slightly below, painting a substantial highlight along the bottom edge makes them appear raised and overlapping. When painting the scales, keep the direction of the light in mind. If lit from above, this surface would look completely different.

5 *Finishing Touches*
Continue to build up your highlights, brushing in extra luster. With a shadow tone, paint around the edges of the scales for further definition. Add some reflected light in the shadows to accentuate the shine. Finally, lightly pull a textured brush over the top of the scales to give them more variation.

6 *Add Wear, Tear and Shine*
Add details, like cracks, to break up the uniformity and give personality to the patterns. Glaze on a band of brighter colors over the top of the scales to create an iridescent luster where the light is most intense.

Scale Texture Examples
Be creative with your scales! Experiment with shape, size and color.

When painting fur, it can help to look at different animals' furs under different lighting conditions (many photographers graciously provide free stock on DeviantArt or their own websites). If you've ever handled furs, you've probably noticed rabbit fur looks and feels different from skunk or coyote fur—a good thing to keep in mind while you paint.

Many pelts aren't a single uniform color like gray or orange. Instead, they are a mixture of colored strands that create a more unified color. A gray coat on closer examination may be a mix of black, white and silver fur strands. Mixing a variety of colors into the clumps brings a heightened sense of naturalism to the fur.

The shape of the animal (as well as general fur direction, what part of the animal, etc.) dictates shadow placement, but usually I'll block off chunks of fur before going further with rendering smaller locks of fur. I rarely detail individual strands, but it can be nice in bright lighting to have a few standing out. It makes the fur look more organic and less combed.

1 Apply the Base Tone
As with scales, start with the base color. Work in some basic tonal variation to define the area's form.

2 Define the Fur Shape
For an animal with thick or long fur, it's helpful to start by blocking off the fur into large chunks. Fur has natural flow patterns as it runs down the body. Be sure to depict this directionality through the overlapping sections.

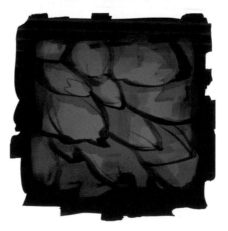

3 Add Color Variation
Apply some lighter tones to add volume and color variation to the fur.

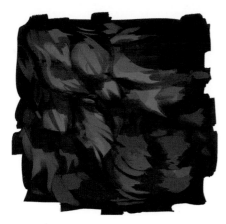 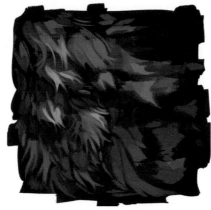 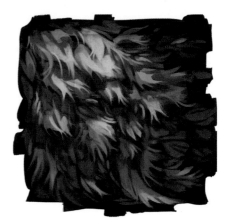

4 ***Divide the Fur Into Smaller Clumps***
Using loose, energetic brushstrokes, work your way through each fur clump, further dividing it into smaller, jagged sections. Pull your strokes along the path of fur from its origin to the tip. Consider the overall lighting as you build up your shadows and highlights; don't shade each section equally. Seek to create a flow from light to dark to help guide the eye.

5 ***Build Up Shadows and Highlights***
Continue the fur subdivision process, adding detail and color variation to each section. To give the fur more dimensionality, brush a dim secondary light source into the shadow areas. Continue focusing on shapes—don't worry about painting wispy individual strands.

6 ***Finishing Touches***
Carry the refining process of building up shadows and highlights through the rest of the fur. Add a few light textured brushstrokes to finish.

Fur Texture Examples
Fur comes in a variety of shapes, lengths and textures.

Rabbit & Dragon: Exploration

I want to take you through the creative process for making a full-scale illustration. For larger paintings like this, I start by gathering references and researching. Then I eventually graduate to sketching potential compositions in the form of small thumbnails. Once I find a thumbnail I'm happy with, I trace over it in Photoshop to make a more refined sketch. Then I'll add rough colors and shadows, and paint atop those with successive passes, detailing until the image is complete.

When I'm working on simpler illustrations and speed paintings, I usually skip straight to the sketch phase. But, with more involved pieces, it's a good idea to plan and explore to discover the best way to approach the image. That way you can work out any issues before you spend twenty hours painting it! The extra time spent on planning will pay off in the finished piece.

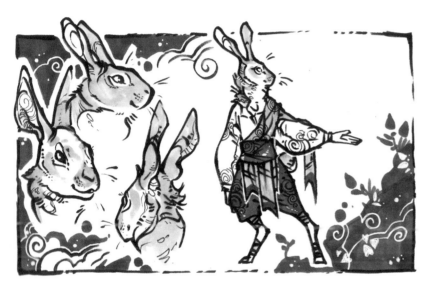

Rabbit Exploration Doodles (2013)
Digital, 5½" × 8½" (14cm × 22cm)

There's something appealing to me about a cute little rabbit being able to summon/fight/befriend a giant dragon. I also find I can associate human qualities more easily with the rabbit.

Dragon Exploration Doodles (2013)
Ink and marker on sketchbook, 5½" × 8½" (14cm × 22cm)

The dragon took a little more brainstorming than the rabbit. I looked at a ton of different reptile and fish heads for inspiration—extinct and deepwater fish have some really neat designs—and eventually decided on some sort of crocodile hybrid. The dragon's snout became unintentionally shortened in the sketch, so rather than a thin gharial snout, he ended up having more of a standard dragon head (whoops!). I gave him a serpentine body to allow for more options when planning compositions. The scales aren't as realistically shaped as I usually draw them. Instead, the final design inspired me to go more playful with a diamond scale pattern throughout the whole body.

Composition Tips

Composition is one of those tricky areas that can take a while to get right. Here are a few tips for creating balance and flow in your illustrations.

Bad: No Spiral

Avoid dividing your composition in half. The strong horizontal leads the viewer's eye right off the page without having looked at your illustration first.

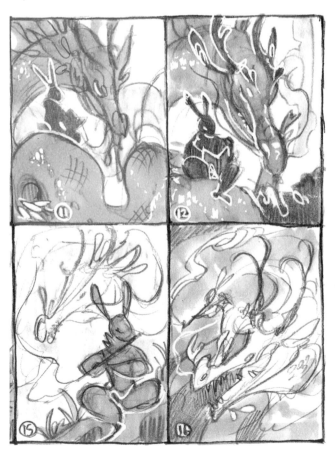

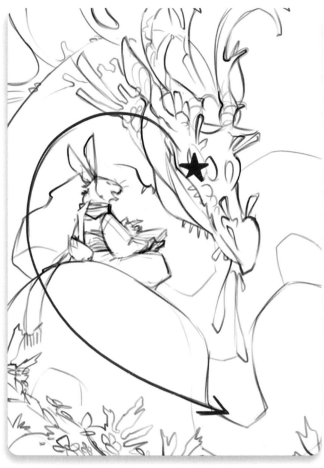

Follow the Spiral

Try to lead the viewer's eye through the entire painting. Arrange elements of your composition so they create a path through the image. Avoid elements that block or disrupt the flow.

Thumbnails

Thumbnails are an easy and quick way to test out a composition, idea or even a color scheme before you invest a lot of time in it. They allow you to focus on the overall image without getting caught up in the details.

Mirror Trick

Is your illustration still not looking quite right? Try flipping your painting for a fresh look. This allows you to spot flaws more easily. Traditional media artists can flip their image by using a light board or by holding their picture up to a mirror. I tend to do the mirror trick every thirty minutes or so while I paint.

Rabbit & Dragon: Painting

1 Clean the Sketch
Refine your thumbnail into a clean and easy-to-read sketch. Don't worry about drawing details. Focus on the main forms and positioning of elements. It's possible to skip this step, but it's easier to correct anatomy or character placement when there isn't any color in the way.

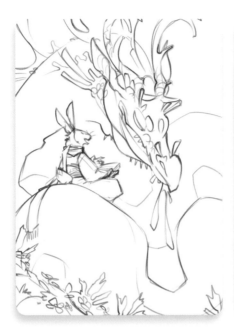

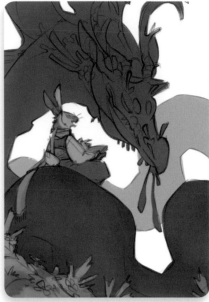

2 Block in the Foreground Colors
When you have a specific color scheme in mind (here, purple, brown and green), I find it helps to lay down the base colors before messing with lighting. With an especially complex piece, you may want to confine background and foreground elements to their own layers for easy adjustments.

3 Additional Layering
Block in the background colors. Once the entire canvas is filled, make a new layer or two for light and shadow. Use warm or cool colors to add contrast and depth to the shadows; avoid gray tones. I like to experiment with changing the layer blend modes (my favorite is Color Burn because it enhances the richness of the colors).

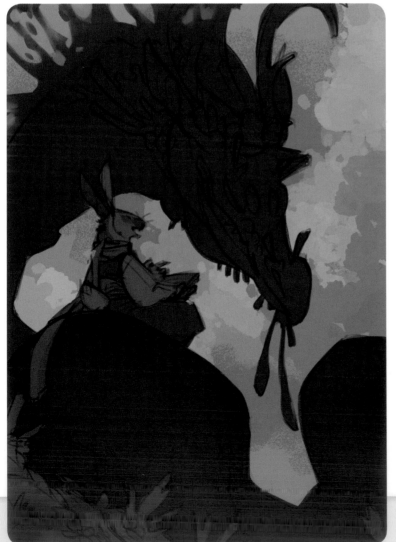

4 Adjust the Colors

To indicate a light source coming from the background, paint a lighter edge around the characters and darken the foreground. Working from back to front, make color tweaks as needed—the Selective Color tool in Photoshop is your best friend for this. Use extra layers, as I did here for the distant tail segment, to make adjustments without destroying anything.

5 Begin Painting

With the colors in place, you're ready to paint! I find it's generally better to start with the background. You don't usually need to make it as detailed as your characters. Details draw the eye, so too much detail in the wrong place can be bad; it competes for your focus. You can always return to the background later if you need to tighten up things.

6 Paint the Dragon's Face

Make a new layer above the sketch lines and switch over to detailing the characters. I choose to start with the dragon's face. I usually go back and forth between shadow and light, bringing the details into focus.

7 Add Details

Carefully work your way through the dragon, one section at a time, taking care to retain the sense of form as your colors begin to cover the underlying line art. The detailing slowly migrates outward along the head and down to the body.

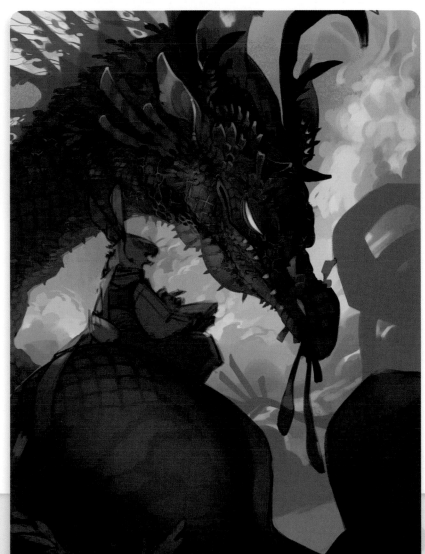

8 Continue Detailing

When the dragon is far enough along, start tightening up the background. Keep the background values lighter with less contrast. This will prevent it from competing with the foreground and give it a misty, atmospheric quality, helping create a feeling of distance. I've also added scales to the farthest back part of the tail. A few sparkles in the clouds add motion and a touch of magic to the scene, completing the background.

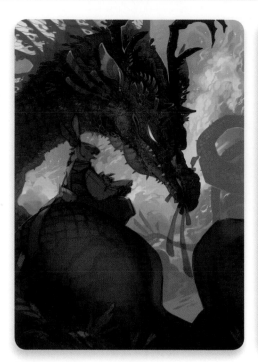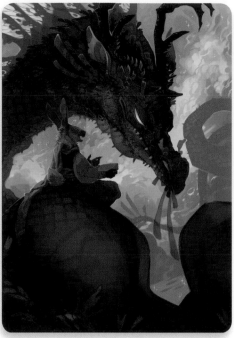

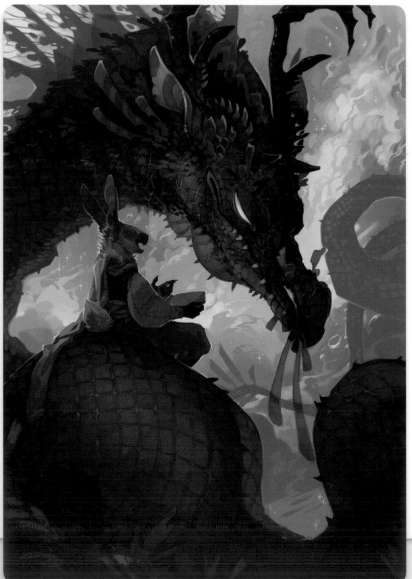

9 Paint the Rabbit

The rabbit is the next step. The background is done at this point, so it's simple to paint him without worrying about what's behind him. Approach the rabbit like the dragon, one section at a time, painting over sketch lines with color and value.

10 Paint the Foreground Details

Finally, it's time to move on to the elements in the extreme foreground, such as the rest of the dragon's tail scales. I also painted a brighter edge along the rabbit's back to separate him from the background, and I lightened the inside of the dragon's nostril.

Tip

At this point, if you have the time, it's nice to shelve a piece for a few days and return to it with fresh eyes—especially if something about the piece is bothering you.

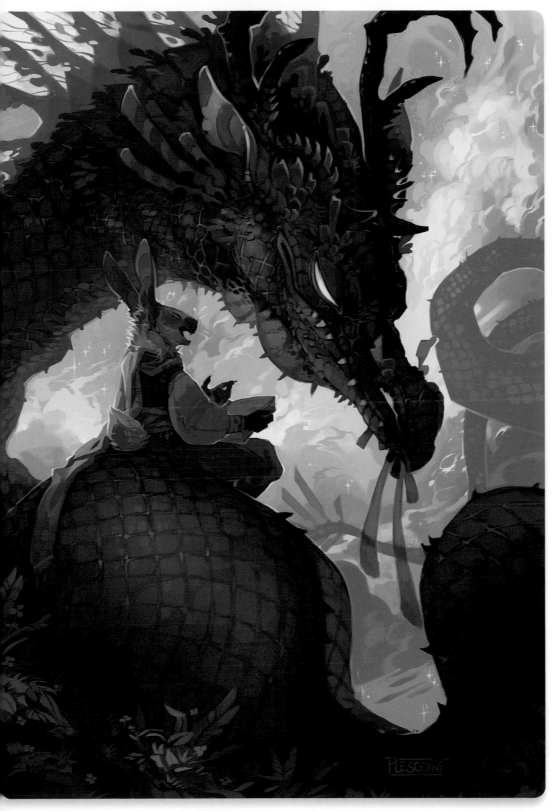

11 *Finishing Touches*
All that's left are the grass and plants near the bottom. Plus, I usually do a final color adjustment and see if I missed any spots. The Sharpen More filter, selectively applied, is useful for tidying up any slightly blurry brush marks.

Storyweaver (2013)
Photoshop

CHAPTER FIVE
CookieHana

Jennifer Lynn Goodpaster Vallet (CookieHana) is a self-taught digital artist from Spain. Jennifer has been drawing since she was very young. At the age of 15, she started drawing anthropomorphic characters and has been making them ever since. Over the years, art has transformed beyond a hobby into a serious profession for Jennifer. Currently, she works as a freelance illustrator and character designer taking art commissions. Her work has appeared in several books including *Draw More Furries*, the *Symphonic Sky* art book and the *Courage Charity* art book. Jennifer has two lovebirds, Wasabi and Ginger, which she considers the cutest things ever.

Sakiko
PaintTool SAI and Photoshop CS5

Style

My style is comprised of flowing lines with high-saturation pastel color schemes, using soft shading and gradients. My specialty is character design with a focus on personality, pose and costume. Traditional Japanese and Chinese clothes, along with fantasy themes, are a real inspiration to me so I usually include those when designing characters and outfits. I also find inspiration from music, especially chill or orchestrated. I prefer to draw hoofed animals, especially horses, and I like long tails, cute big ears and small catlike paws, so I usually incorporate those kinds of features when designing.

Shizuka
PaintTool SAI and Photoshop CS5

Shizuka is a reserved and quiet kitsune/cat hybrid who usually keeps to herself. She's also very cunning. To color her striking kimono, I used a green-to-red rainbow gradient and emphasized the folds with deep shadows. For additional detail, I painted a wavy line pattern and applied a grainy texture.

Bunny With Horns
PaintTool SAI and Photoshop CS5

For this character, I was commissioned to design a short-horned bunny with long, fluffy ears and tail, using a predominantly pink color scheme. As an added touch, I worked a flower motif into the design and painted decorative stripes across the fur and horns.

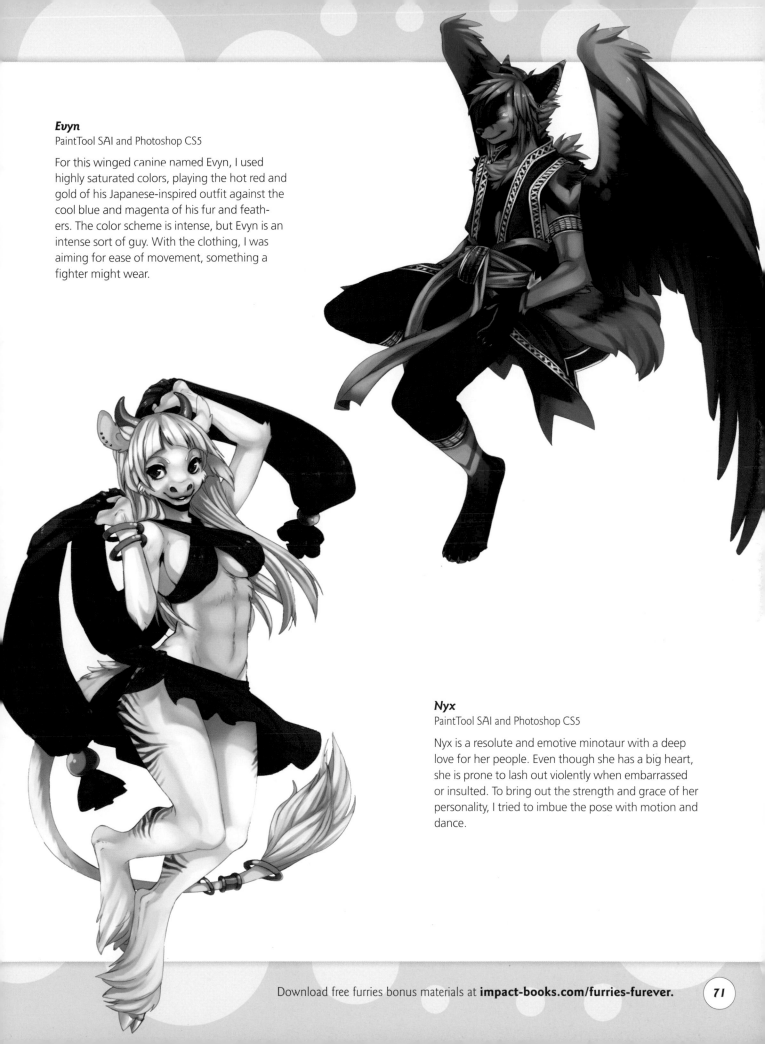

Evyn
PaintTool SAI and Photoshop CS5

For this winged canine named Evyn, I used highly saturated colors, playing the hot red and gold of his Japanese-inspired outfit against the cool blue and magenta of his fur and feathers. The color scheme is intense, but Evyn is an intense sort of guy. With the clothing, I was aiming for ease of movement, something a fighter might wear.

Nyx
PaintTool SAI and Photoshop CS5

Nyx is a resolute and emotive minotaur with a deep love for her people. Even though she has a big heart, she is prone to lash out violently when embarrassed or insulted. To bring out the strength and grace of her personality, I tried to imbue the pose with motion and dance.

Artist's Toolkit

I work in a digital medium for both drawing and coloring. The art program I mainly use for sketching, line art and coloring is PaintTool SAI. I use Photoshop CS5 for adding textures and filters or for fixing colors in the picture. I also use Photoshop for creating backgrounds and painting realistic landscapes and animals.

My sketches in SAI are very loose at the beginning. I scribble random shapes and lines to brainstorm the pose for the character, slowly adding more detail with each pass. Once I'm happy with the rough sketch, I move on to the line art. I make quick pen strokes to produce flowing and smooth lines, using frequent Undos to erase any mishaps, and then redraw the lines until they're just right.

Then I move on to coloring and shading, my favorite part of the process. First, I fill the character with a base color (usually white over a dark background) and lock the layer to prevent coloring outside of the lines. When coloring, I try to keep the layers to a minimum to reduce confusion. I generally use one layer for the character (skin/fur, hair, etc.) and one for the clothing and other details. After the coloring is done, I open the picture in Photoshop to add any finishing touches.

Materials list

- Laptop
- PaintTool SAI
- Photoshop CS5
- Wacom Bamboo Fun tablet

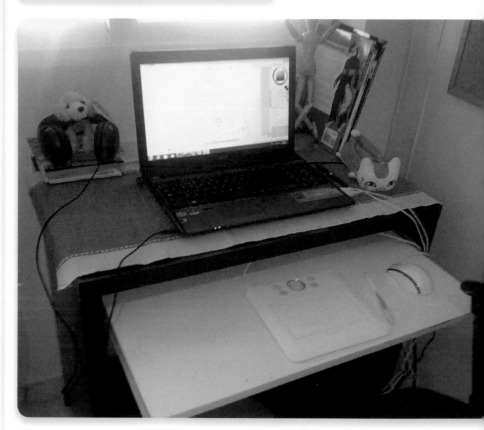

Work Space

This is my work space. I don't have a whole lot of tools aside from the laptop and Bamboo tablet, but that's all I need to create my art. I also have a little wooden mannequin to play around with if I'm having trouble coming up with poses.

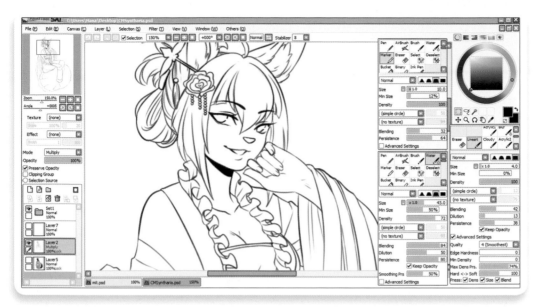

PaintTool SAI

PaintTool SAI is a lightweight and easy-to-use art program. Although it lacks certain features found in Photoshop like filters, effects, animation and other image adjustment tools, SAI is a great program for drawing and painting. Choose from a variety of brushes and they can be customized to your liking. It offers layer composition modes, and you can also instantly flip and/or rotate the canvas to check your work.

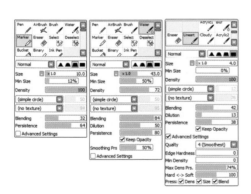

Brush Tool Settings

These are the main tools I use when working in PaintTool SAI. The Lineart tool is a custom brush I made that is similar to the Brush tool but smoother. I use this tool for thick, smooth lines, and the default Pen tool for crisp, thin lines. I use the Marker tool for coloring, blending and shading for a nice painterly effect. I also use the Water brush to further blend and smooth colors if necessary.

Safiyah

This cute feline-weasel character was drawn and colored in Paint-Tool SAI.

Fox: Character Design

For this section, I'll demonstrate how to design a basic anthropomorphic fox character from scratch. By adjusting the body shape, hairstyle and other physical attributes, you can create a unique character even before you add the costume. Note that while I've selected a red fox as my animal subject, these basic tips apply to any species. Also, reference images can help you get the details just right and give you a strong basis to work with for your animal character. So always start by collecting reference material, especially if you're unfamiliar with the species.

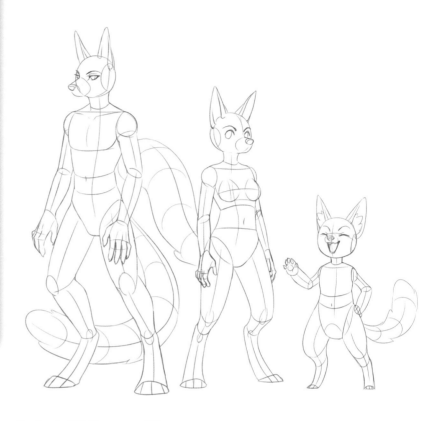

Visit to the Hair Salon

Your character's hairstyle is an important aspect of its design. First draw the shape of the head, then try sketching different hairstyles until you find one you like. Remember to leave space for the ears to poke through. Add hair accessories and experiment with ponytails and braids for further styling. Browse hairstyle magazines as inspiration for trendy styles.

Bodies in All Shapes and Sizes

When designing a character, it's always fun to experiment with different types of body shapes. This will help set your design apart from others and may help inspire your character's personality and abilities. Start by drawing different shaped figures like tall and muscular, short and curvy, petite and cute, more animal-like, etc. You can get a wide variation by simply adjusting the proportions.

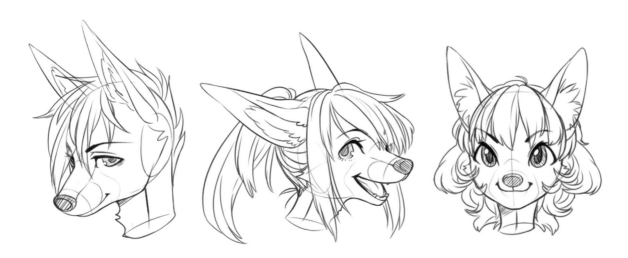

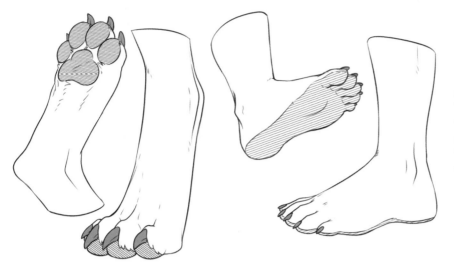

Foot Styles

There are many foot or paw configurations. A digitigrade foot (left) walks on its digits with the heel lifted off the ground. The human-like plantigrade foot (right) walks on the full sole of the foot.

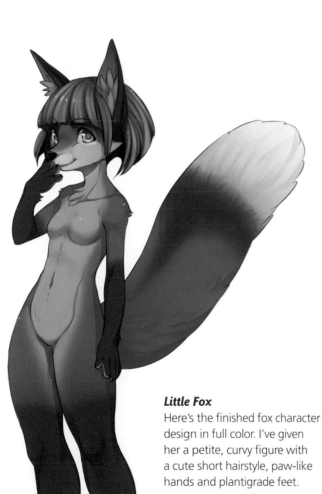

Little Fox

Here's the finished fox character design in full color. I've given her a petite, curvy figure with a cute short hairstyle, paw-like hands and plantigrade feet.

Hand Styles

There are numerous ways to approach drawing anthropomorphic hands, from mostly human to more animal-like with short and stubby fingers, claws and paw pads, or something in between.

Fox: Costume Design

The next part of the character design process is developing a clothing theme for your character. Before you start, it's helpful to have a setting in mind and know a little about the history and personality of your character. These details will give you more inspiration to work with and avoid design dissonance. After all, you wouldn't want to make a modest character wear something that shows a lot of skin or have it wearing fantasy-esque armor in a normal world setting.

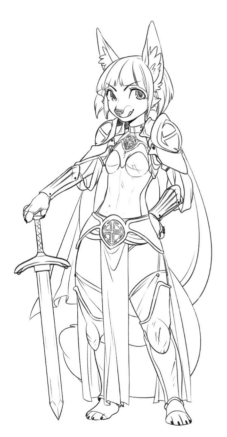
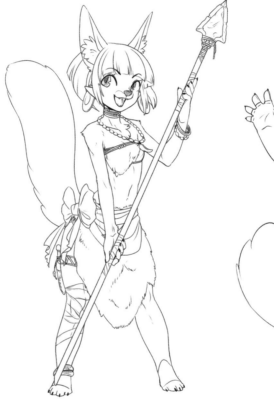

Fantasy Theme
Who says small characters can't be tough? Here our little fox models medieval-inspired armor with a fantasy touch. To soften the metallic portions of the armor, I added fabric elements to the design, such as the cape, sleeves and waistcloth.

Jungle Theme
Here I've given her an Amazon look. Her clothing consists of pelts from animals she's hunted with a handmade spear, along with woven fabrics and beads.

Sci-fi Theme
The fox wears a futuristic suit for piloting her spaceship and robot. Her outfit consists of form-fitting garments, a bit of light armor and a helmet.

Fun Facts
Anthropomorphic kimono-clad foxes, raccoons, dogs and cats were a re-occurring subject in classical Japanese ukiyo-e artwork.

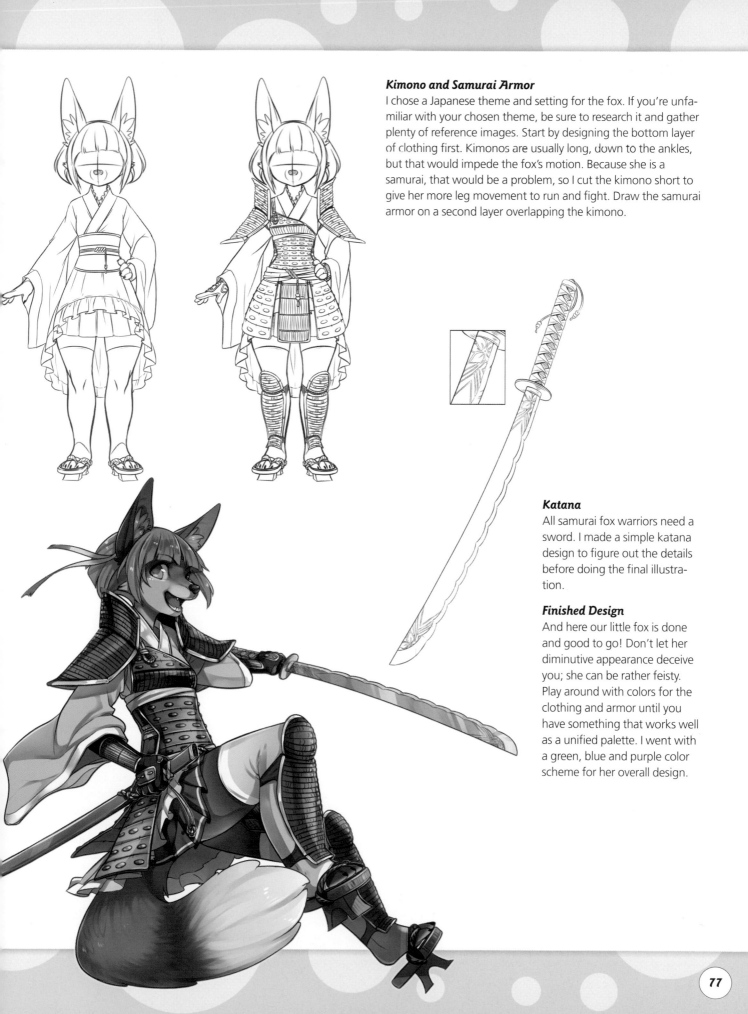

Kimono and Samurai Armor

I chose a Japanese theme and setting for the fox. If you're unfamiliar with your chosen theme, be sure to research it and gather plenty of reference images. Start by designing the bottom layer of clothing first. Kimonos are usually long, down to the ankles, but that would impede the fox's motion. Because she is a samurai, that would be a problem, so I cut the kimono short to give her more leg movement to run and fight. Draw the samurai armor on a second layer overlapping the kimono.

Katana

All samurai fox warriors need a sword. I made a simple katana design to figure out the details before doing the final illustration.

Finished Design

And here our little fox is done and good to go! Don't let her diminutive appearance deceive you; she can be rather feisty. Play around with colors for the clothing and armor until you have something that works well as a unified palette. I went with a green, blue and purple color scheme for her overall design.

Basic Head Shape

Gypsy horses are gorgeous animals with the sturdy build of draft horses and petite, elegant heads. Their coats can be any color, but black and white pinto (color patches) are most common. They have abundant mane and tail hair and ample leg feathering covering the entire hooves. As you follow along the character design process from sketch to color, focus on bringing out the strength and grace of the breed.

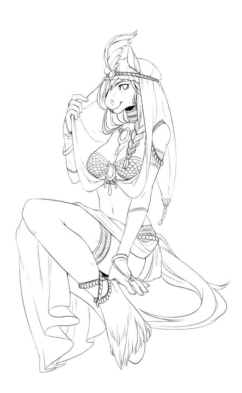

1 Sketch the Figure
In PaintTool SAI, start by drawing the character in a seated pose using rough shapes. Keep the sketch loose and without details. Build upon the body structure with the ears, hooves, hair and tail.

2 Sketch the Clothing
Make a new layer above your sketch and choose a different color to differentiate the lines. Our horse anthro is a skilled dancer, so give her a costume that suits her profession and allows her to move gracefully. Consider the overall design, and remember you can use the Internet and other resources for helpful reference.

3 Create the Line Art
Turn down the opacity of the sketch layers, and make a new layer above them for the line art. Using the Lineart brush, carefully detail the figure with smooth, flowing lines. Don't be afraid to undo multiple times to get just the right line. When you're done, you can delete the rough sketch.

4 Apply Flat Colors

Make several new layers beneath the line art, one each for the body, hair, clothes and accessories. Fill each area with a base color tone. Paint the dark fur patches over her white coat on the body layer, and use the Water brush to soften the edges. Add pink tones to the muzzle and ears.

5 Add Shading

Lock your color layers so you don't paint outside your lines. Switch to the Marker brush to add shading to each area. For the body, do the shading on a new layer set to Multiply to avoid messing up the fur patterns. Then, add highlights to the shiny metallic areas of her outfit.

6 Finishing Touches

On a new layer, add highlights to the clothing, hair and eyes. For a nice softening effect, lock the line art layer and use the Pen or Airbrush to selectively tint the lines with a color darker than the surrounding colors. Place the character on a neutral-tone background to bring out both the lightsand darks of the image. Then open the image in Photoshop for final color adjustments.

Cat-Owl Hybrid

Basic Head Shape

In this demonstration, we'll combine the traits of two distinct animals—a cat and an owl—to create a hybrid character. To make each animal type a recognizable part of the design, use a blend of their most prominent features, such as the owl's wings, talons and leg feathering, along with the cat's face, ears and tail. As always, study reference images to familiarize yourself with the details of the animals you're drawing.

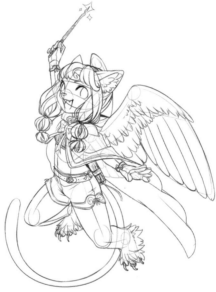

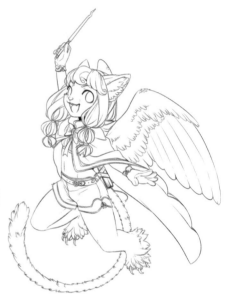

1 Sketch the Figure
Start by drawing the basic form of the cat-owl. Keep your sketch loose at this stage. Give her a small body and a jubilant pose to bring out her cuteness. Add the ears, hair, talons and tail. Build up the wings, first as simple shapes, and then the feathers.

2 Sketch the Clothing
Make a new layer above your sketch and choose a different color to differentiate the lines. Our little cat-owl hybrid is a cheerful magician, so give her fantasy clothing that fits her setting and personality. Don't worry about the details yet.

3 Create the Line Art
Lower the opacity of the sketch layers. Create a new layer above the sketch layer, and make a clean pass on the lines using the Lineart brush. Use additional layers for each area, like hair and clothing. Keeping the areas separate lets you easily resize and rotate parts to make corrections as you work. When she looks ready to leap off the page, merge the line art layers.

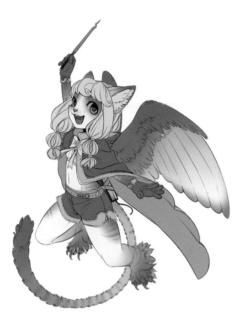

4 Apply Flat Colors
Beneath the line art, make new layers for the body, hair and clothes. Fill each area with flat color, then lock your layers to prevent coloring outside the lines. On the body, add some brown patches over the cream-colored fur. Soften the edges of the patches with the Water brush. Then add stripes with a darker shade, and use the Water brush to soften them.

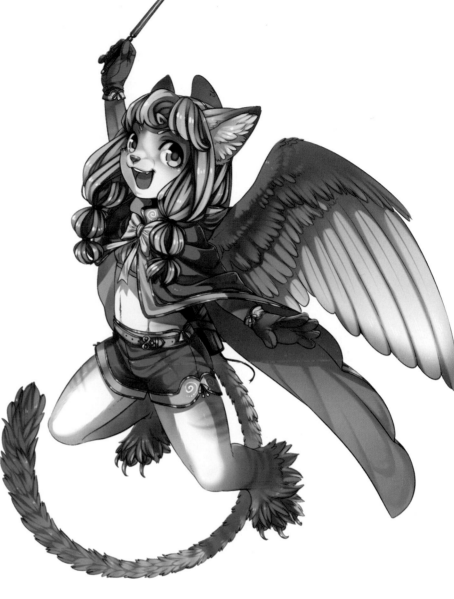

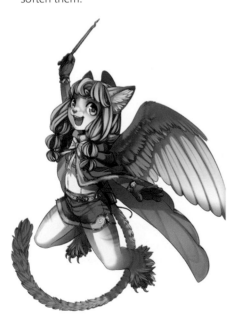

5 Add Shading
Using the Marker brush, add shading to bring out the character's volume. For the body shadows, make a new layer set to Multiply to avoid messing up the fur patterns. To give her outfit a gold trim, alternate between dark browns and yellow highlights. Create a new layer above the line art to add highlights in the eyes and swirl patterns on her outfit.

6 Finishing Touches
On a new layer beneath the line art, use the Brush tool to add bright highlights to the clothing and hair. Then use the Marker tool to softly blend some blue into the shadow areas for ambient reflected light. Open the image in Photoshop for color adjustments. Duplicate the art on a new layer, and set it to Soft Light, 20% Opacity. Apply a blur filter to the layer to soften the image.

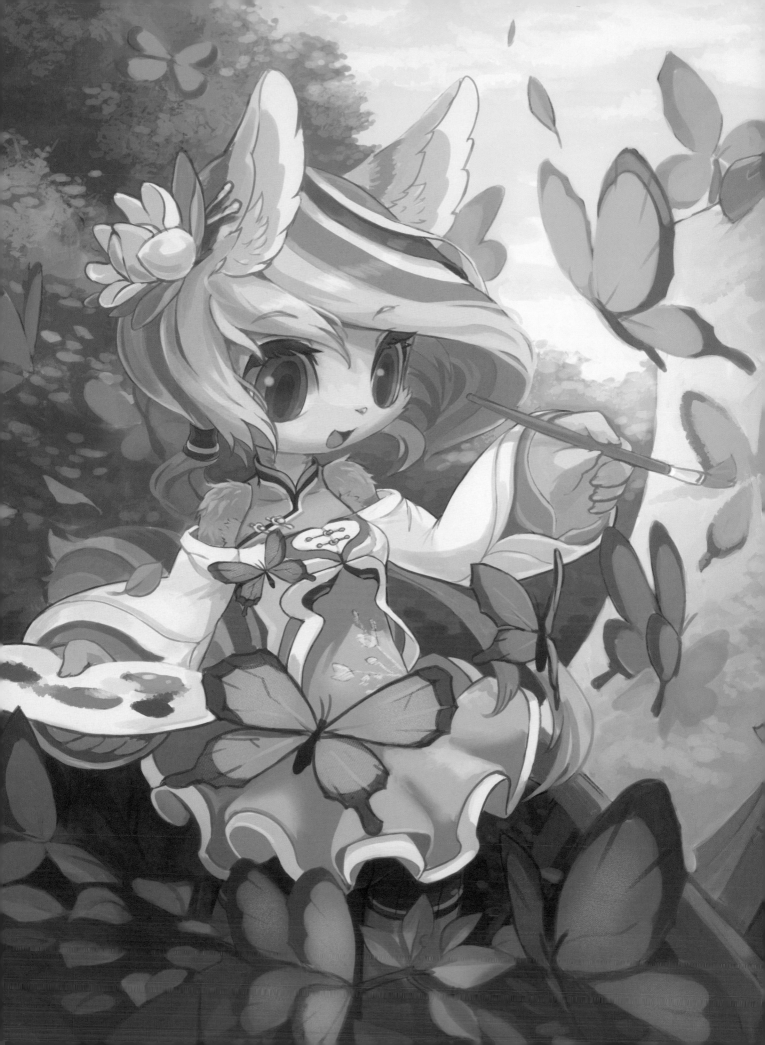

CHAPTER SIX
Tyson Tan

Tyson Tan lives in Dongguan, a southern Chinese city near Hong Kong. He was attracted to the furry genre by cartoons. Inspired by sci-fi TV shows and games, he began to experiment with adding cybernetic elements in his designs. In college he majored in industrial design and used his knowledge to develop a signature art style of organic-looking anthropomorphic androids. Tyson works mainly within the sci-fi genre and provides mascot designs for various free and open-source software projects. He has been using only free and open-source software as creativity tools since May 2012.

Drawing from Life
Digital

Style

As a graduate student of industrial design, I always place design as my highest priority in the creative process. Like many other designers, I work in a rational way. I will spend considerable time researching a subject before I proceed to drawing. In my research, I depend on college textbooks as the primary source of knowledge.

I try to keep my digital painting process simple. I generally use the default brush set in Krita with a small number of layers, an approach similar to acrylic painting. Many of the elements that I use are inspired by folk costumes and plants. Although I draw some conventional furry characters, my signature style involves drawing anthropomorphic characters in a cybernetic/robotic way. As a Chinese artist, I frequently use traditional Chinese color combinations to show my national identity. I prefer small and less aggressive animals like rodents, rabbits, small birds and foxes as my subjects.

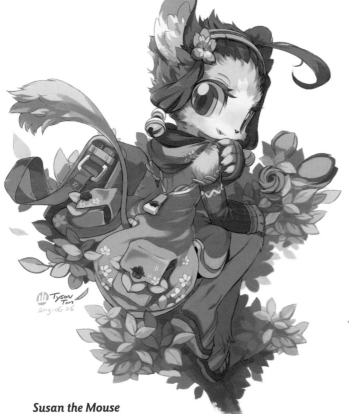

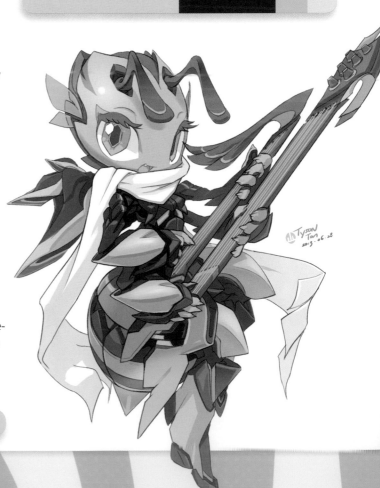

April the Robotic Bee
Digital

Insects have a sleek and blocky body structure that is easy to adapt into robotic characters. The blue-cyan glows give a high-tech impression, while the geometric shapes add an industrial touch to her body that resonates with her robotic nature.

Susan the Mouse
Digital

The main theme of this character is *flowers in the leaves,* an element that re-appears in the shapes, patterns and color scheme of her design. A simple background of flowery bushes blends nicely with the character, suggesting the relationship between the character and the main theme.

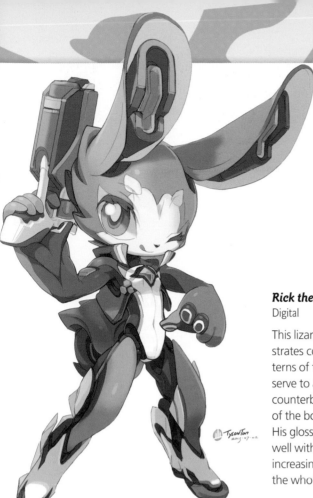

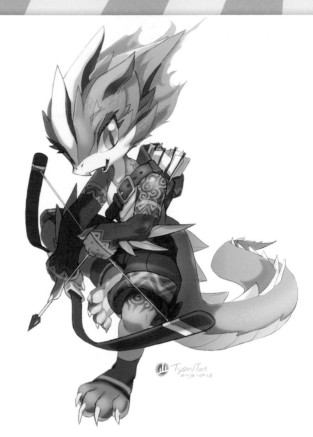

Rick the Lizard
Digital

This lizard character demonstrates contrast. The denser patterns of the left half of his body serve to attract the eyes and counterbalance the prominence of the bow in his right hand. His glossy scales also contrast well with his matte clothing, increasing the visual interest of the whole design.

Viola the Robotic Rabbit
Digital

Although the character is robotic, her color patterns are divided in the same way as many real animals (lighter color in the face-to-belly part). Other animal traits appear throughout her body structure, reminding the audience that she is derived from a rabbit.

Phinny the Quetzal
Digital

The red and green of this quetzal's color scheme generally don't work well together. In the design of this character, however, green occupies a much larger area than red, which confines the intense contrast to her torso. Other colors, especially dark green and white, were added to alleviate the intensity of the red and green, generating a rhythm and achieving an overall harmony. Red and dark green are repeated throughout the design to provide some degree of consistency.

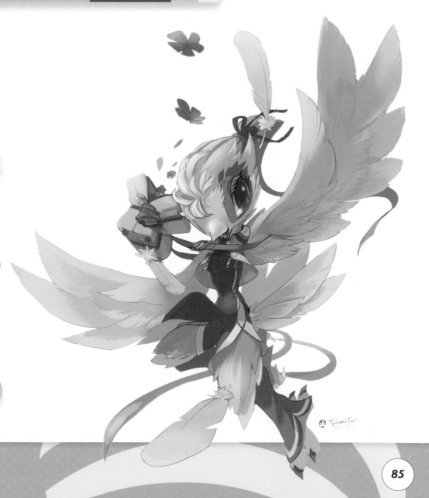

Artist's Toolkit

I will sometimes use pencil and paper to play with concepts, but when it comes to serious drawing, I work almost 100 percent digitally. My equipment includes a laptop, an external display and a graphics tablet. To ensure my freedom of creativity, I gave up using proprietary software in May 2012 and now use only free and open-source software. Krita and GIMP are my tools of choice.

Fun Facts

The term *kemonomimi* (Japanese for animal ears) can be used to refer to human characters with animal ears and tails.

Materials list

Hardware

- External monitor—Get at least a 22" (56cm) display with a minimum resolution of 1280×800. If color accuracy is your concern, you can buy a color calibrator to correct your display.
- Graphics tablet—You can use your mouse (or even a touchpad) to draw, but it's a good idea to get a graphics tablet so your computer can trace your stroke more precisely with the glorious pressure detection.
- Laptop—You don't even need a high-end graphics card because 2-D digital painting applications don't substantially depend on it. Invest your money on a better CPU and more memory instead.

Software

- GIMP—For image manipulation and typography
- Krita—Free and open-source software for drawing and painting
- Ubuntu—Operating system

Krita and its multipurpose right-click palette.

Character Design Basics

Character Profile

To design a good character you should start with preparing his or her profile. A well-prepared profile defines every single trait of a character. You can include many things in a character's profile, but here's a good place to start:

1) What is the character? (species, gender)
2) Who is the character? (history, where they live, culture, ancestry, occupation)
3) How does the character behave? (personality, habit, social relationships)

What is the character?

He is an anthropomorphic rabbit with gray fur/white chest and stomach. To make his gender more obvious, I gave him shoulders wider than his hips as well as shorter eyelashes.

Your job as a character designer is to make a great character that is consistent, believable and easy to understand. Design can be roughly described as a two-part process:
1) Think up a great idea.
2) Effectively communicate with your audience about your great idea.

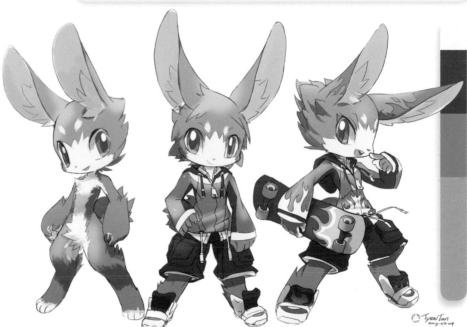

Who is the character?

He is a city dweller in a country dominated by modern western culture so the color scheme is mostly monochromatic. Also, to make his facial expression easier to read, I added higher contrast and richer details around his face and chest.

How does the character behave?

He is cocky and mischievous. I adjusted the shape of his eyes to be more angular, added fire patterns on his shirt and dyed the hair on his ears to better convey his aggressive and energetic personality.

Color Choice

Color Bars

Make each part of your color scheme a different percentage of surface size to create visual interest.

Contrast and Repetition

Notice how colors of different saturation and luminosity interact with each other in this picture. There's contrast of size: small decorations vs. large areas of clothes, and contrasting textures: glossy hair vs. silky Chinese dress vs. matte leg warmers. An iconic flower pattern repeats throughout her design and functions as her main theme.

DEMONSTRATION
Rodent

In this demo, I'll show you how to design two different furry rodent characters from start to finish. One is a boy from a sci-fi setting, and the other is a girl from a fantasy world. You will learn how to use a character profile to guide you through the design process and to use colors, shapes and contrast effectively to generate visual interest.

Both characters are jerboas. Little round ears and long, thread-like fluffy tails are traits of the species. By stressing their signature traits, you can make your characters look more specific and believable.

Character Profiles

The boy: A future warrior from some sort of resistance force. He is a cool but reckless fellow.

The girl: A kind-hearted hunter from a wood elf village with a Chinese cultural background.

1 Line Art
Give each character the appropriate features.

Give the boy stiff-looking fur by applying straight and spiky lines. This, accompanied by his wide shoulders and spread-legged pose, helps show his masculinity.

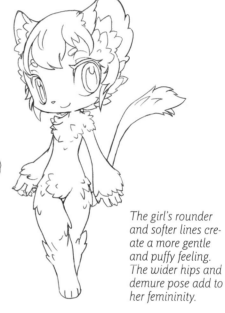

The girl's rounder and softer lines create a more gentle and puffy feeling. The wider hips and demure pose add to her femininity.

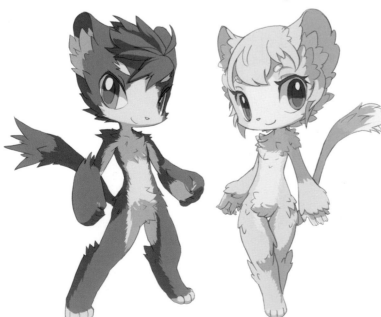

2 Fur Color Scheme
I chose a dark gray for the boy and a cuter bread-like color for the girl. The color on the chest and belly of the boy is lighter to create a stronger contrast. With his glowing cyan eyes, he looks even sharper. The same area of the girl, however, is similar to her dominant color to create a weaker contrast that suggests a milder nature.

3 Basic Clothing

Because the characters are meant to be warriors, give them basic clothing suitable for easy movement and dynamic poses.

I used black and aqua green for the boy to make him look cooler and to remind the audience of his military background.

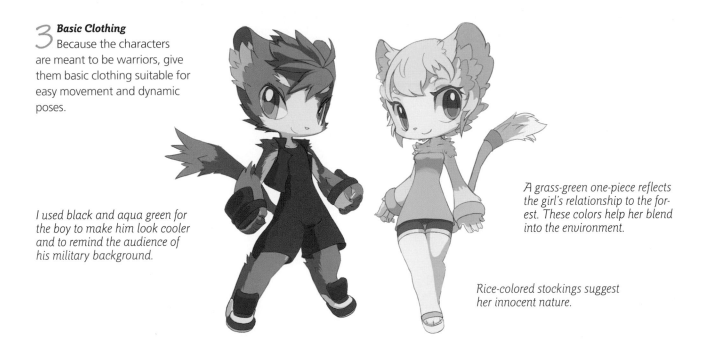

A grass-green one-piece reflects the girl's relationship to the forest. These colors help her blend into the environment.

Rice-colored stockings suggest her innocent nature.

Boy's Color Scheme

Girl's Color Scheme

4 Color Mixing

Experiment with crossing one color into another. In doing so, you may find ways to increase the contrast of your character, or discover an interesting color combination that you can use later when you are doing a more detailed design.

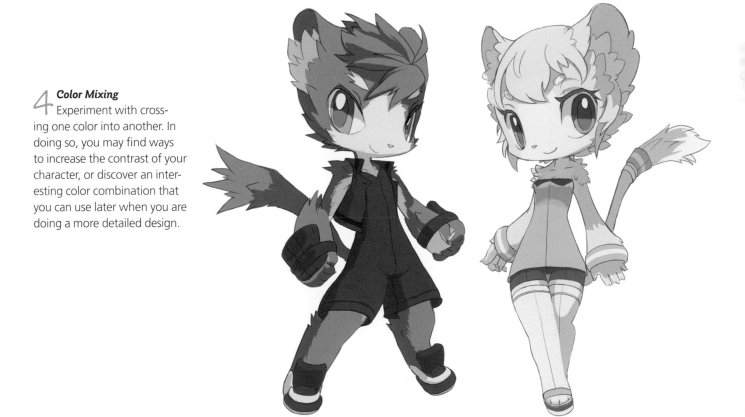

5 Costume Details
Give each character more detail to liven them up.

Parallel stripes of black and aqua green, as well as cyan decorations appear throughout the boy's costume. You can use repetitive elements like these to create an impression of uniformity. This sometimes creates a signature trait for the character.

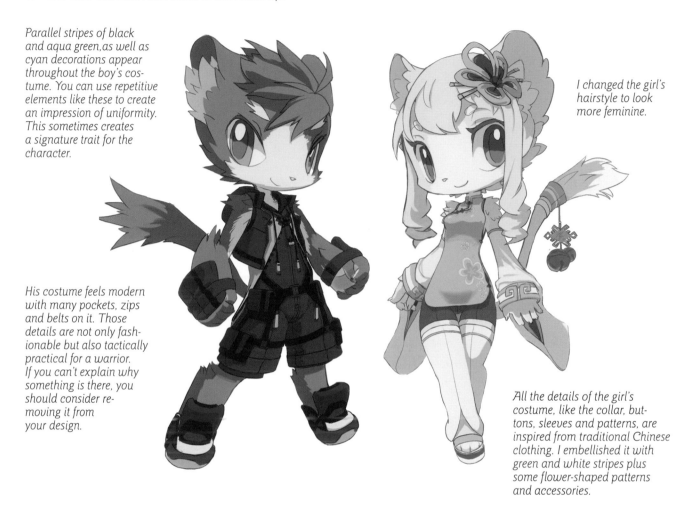

I changed the girl's hairstyle to look more feminine.

His costume feels modern with many pockets, zips and belts on it. Those details are not only fashionable but also tactically practical for a warrior. If you can't explain why something is there, you should consider removing it from your design.

All the details of the girl's costume, like the collar, buttons, sleeves and patterns, are inspired from traditional Chinese clothing. I embellished it with green and white stripes plus some flower-shaped patterns and accessories.

Contrast, Repetitive Elements and Clarity

To enhance your character's visual impact, you must learn to harness the art of contrast and repetitive elements effectively. Contrast is created by differences in color, shape and texture and can help make a part of the design stand out better. Repetitive elements are anything that re-appears in the design multiple times, like a specific set of colors, a distinctive shape or an emblem. Repetitive elements help unify the design as a whole and establish a main theme. Although it is certainly a virtue to make things look fabulous, your aesthetic communication is less than successful if the audience cannot understand what you are trying to describe. Make sure everything in the design is clear and easy to read.

6 Final Costume and Gadgets

Here, I accessorized the characters with a few gadgets. Gadgets give your character something to work with or hold so they aren't just standing there lifelessly. Choose gadgets that reflect the characters' personalities, purpose and world setting. The design of our two rodent characters is now finished. Although we started with the same species, we ended up with two distinctive, original characters. Our characters' profiles played an important role here because they gave us clear directions to follow during the design process.

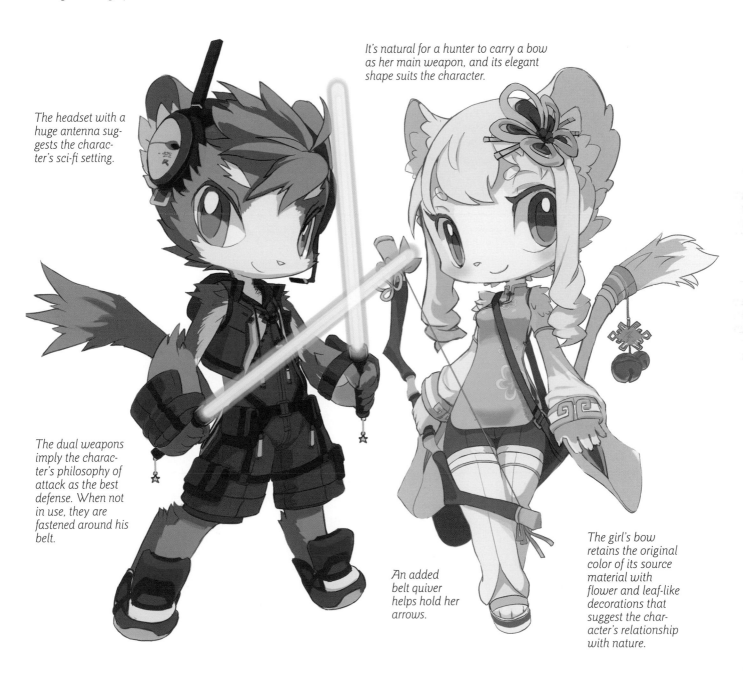

It's natural for a hunter to carry a bow as her main weapon, and its elegant shape suits the character.

The headset with a huge antenna suggests the character's sci-fi setting.

The dual weapons imply the character's philosophy of attack as the best defense. When not in use, they are fastened around his belt.

An added belt quiver helps hold her arrows.

The girl's bow retains the original color of its source material with flower and leaf-like decorations that suggest the character's relationship with nature.

Android Bird

In this section, you'll learn how to design a futuristic avian android character. This is an interesting subject because the artificial nature of an android allows you to apply unconventional shapes, colors and materials to the character.

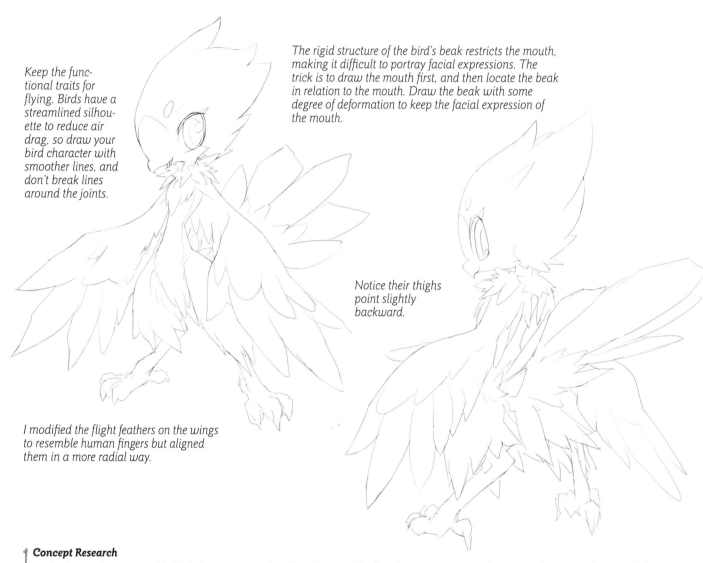

Keep the functional traits for flying. Birds have a streamlined silhouette to reduce air drag, so draw your bird character with smoother lines, and don't break lines around the joints.

The rigid structure of the bird's beak restricts the mouth, making it difficult to portray facial expressions. The trick is to draw the mouth first, and then locate the beak in relation to the mouth. Draw the beak with some degree of deformation to keep the facial expression of the mouth.

Notice their thighs point slightly backward.

I modified the flight feathers on the wings to resemble human fingers but aligned them in a more radial way.

1 Concept Research

Designing anthropomorphic bird characters can be difficult for beginners because avian creatures have a very different anatomy structure compared to humans. One option is to replace their wings with claw-like hands and put a pair of angelic wings on their back to compensate for the loss of flying ability. But here we want the character to look like an actual bird with a believable body structure, so we must experiment to create a believable hybrid of bird and human anatomy.

Feathers have a long, oval shape. Small feathers can be grouped or indicated only with color, but draw the larger, flight feathers one by one, especially when they are along the contour of the figure.

Birds typically have shorter, thinner legs, but their torso and wings are considerably larger.

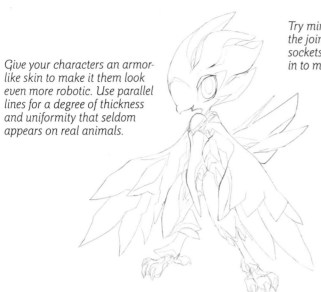

*Give your characters an armor-
like skin to make it them look
even more robotic. Use parallel
lines for a degree of thickness
and uniformity that seldom
appears on real animals.*

*Try mimicking how designers handle
the joints of action figures. Try drilling
sockets on the torso and plug the limbs
in to make them look like robots.*

*While fiddling with the robotic
details, be careful to keep the
outline of the character as
smooth as possible.*

2 Avian Android Design

With the basic anatomy in place, you can more easily convert your character from furry to robotic. The key to making something look like an industrial product is to use geometric shapes and parallel lines. You can find inspiration from automobiles and consumer electronics like cell phones.

3 Flat Colors

In the previous step we added tons of detail to the line art, but that also drastically fragmented the design. You can reverse the negative effect by applying the same color throughout the design. Similar colors glue adjacent blocks into an integrated whole. Here the figure is roughly divided into two major areas: red and dark gray.

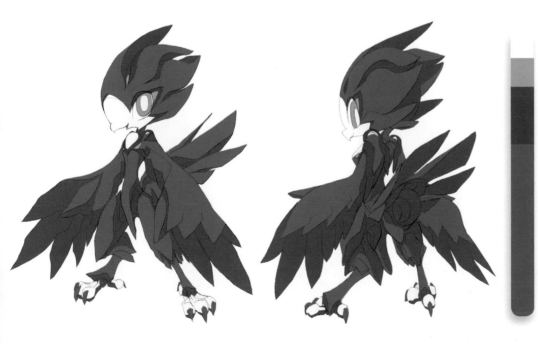

Color Scheme
The formula for the android bird's color scheme is:

- A high-saturation domi-nant color (light red)
- A low-saturation and low-luminosity subordi-nate color (dark gray)
- Two accent colors (white and yellow)

This is a fail-safe color scheme that works on anything because the colors are easy to tell apart and contrast well with each other.

4 Basic Shading

Apply a basic, flat shadow tone to the character. In design art this is mainly used to define three-dimensional shapes and show how different blocks interact with each other.

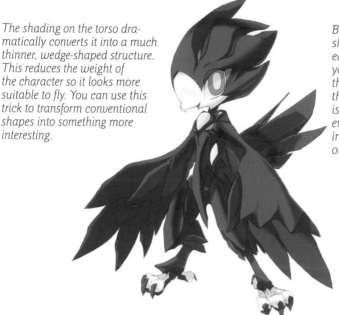

The shading on the torso dramatically converts it into a much thinner, wedge-shaped structure. This reduces the weight of the character so it looks more suitable to fly. You can use this trick to transform conventional shapes into something more interesting.

By applying a thin shadow on the edge of a surface, you can suggest the thickness of the material. This is a useful trick to enhance the visual interest of artificial objects.

5 Basic Highlighting

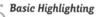

Apply basic highlights to the character. Highlights enhance the contrast of your design, making it look more dynamic. Note how the side of the character's head and the back of the right hand appear to bulge because of the lighter tones.

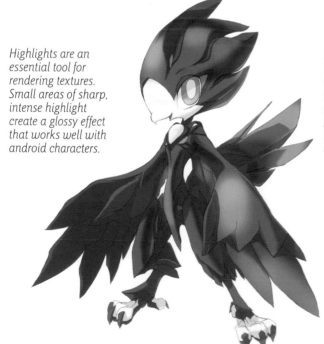

Highlights are an essential tool for rendering textures. Small areas of sharp, intense highlight create a glossy effect that works well with android characters.

Place matte surfaces next to glossy surfaces to create contrast. Remember that areas with a matte finish shouldn't have intense highlights or significant shading.

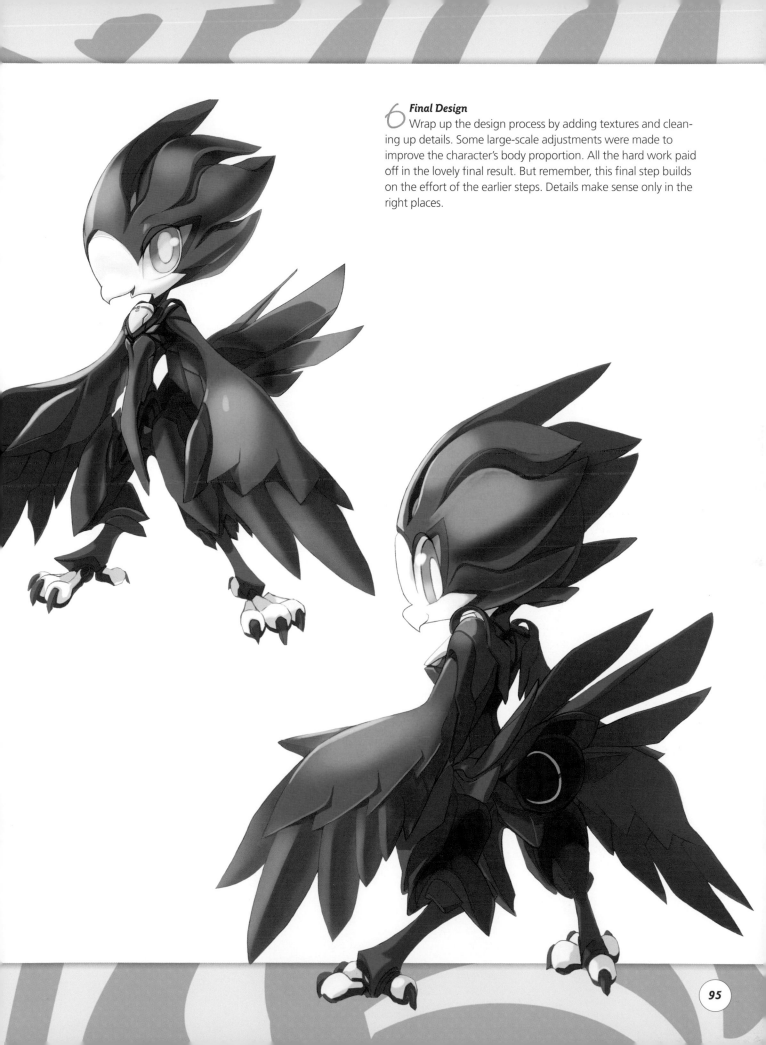

6 Final Design

Wrap up the design process by adding textures and cleaning up details. Some large-scale adjustments were made to improve the character's body proportion. All the hard work paid off in the lovely final result. But remember, this final step builds on the effort of the earlier steps. Details make sense only in the right places.

CHAPTER SEVEN
Kathryn Layno

Kathryn Layno is a freelance illustrator based in Cebu, Philippines. Born and raised in Cebu City, she studied at the University of San Carlos, majoring in advertising. She started her freelance career in 2007 when she moved to Florida. She has worked on several projects including composing music for iPad games and illustrating sketch cards and comics. She lives in Cebu City with her husband and three cats.

Dawn
PaintTool SAI and Adobe Photoshop

Style

My style has no definite form that I stick to, but I do tend to gravitate to quick strokes for my line art. I've always felt it created a more dynamic look that works well with both crisp, thin lines and thicker lines. Basically, when I do line art, it's with a less-is-more approach. Although my work tends to be sharp and minimal, I love sketchy work just as much as clean lines.

Many influences have shaped how I illustrate today. Games, movies, animation and comics have been a staple in my artistic diet since I could remember. The poses I draw are definitely influenced by video game art as well as comic book covers. I try to give as strong of an impression about a character in a single illustration as I could in a few comic pages.

Also, I love using purple hues in most of my coloring. It always gives a sense of ease, and it brings out the warmer colors without being too abrupt. I generally prefer summer colors, probably because I've lived on an island in the tropics most of my life.

Rebel Rebel
PaintTool SAI and Adobe Photoshop

When I'm working on a composition that doesn't have a lot of action, I tend to tilt the character to add a sense of tension and visual interest to the picture. I used an assortment of brushes and textures to make the art appear messy, sketchy and chaotic. The bright colors also bring out a threatening intensity.

Fun Facts

Fursuiting is a creative sub-genre of the furry fandom, involving wearing and/or making animal costumes.

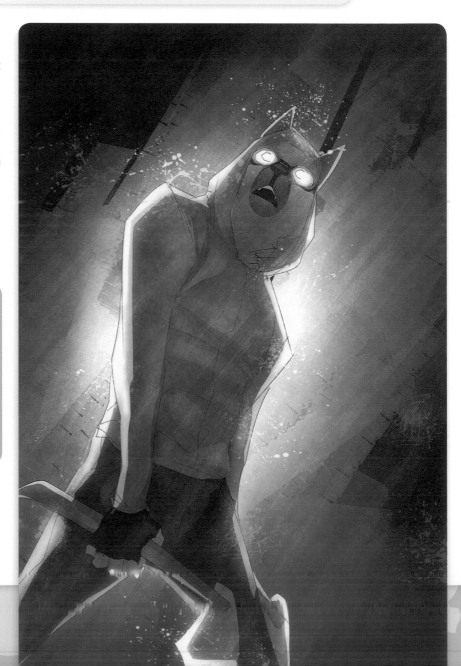

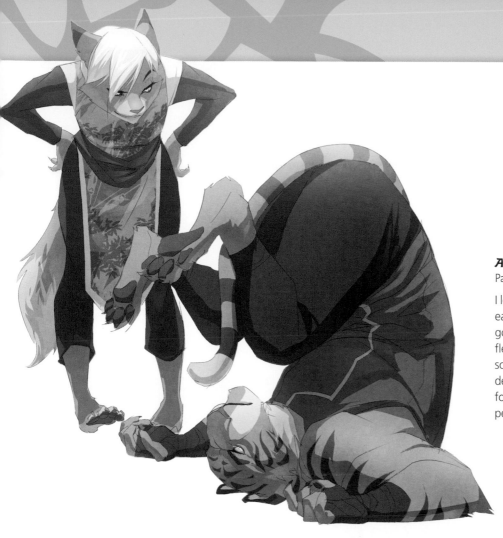

Another Round?
PaintTool SAI and Adobe Photoshop

I love drawing characters interacting with each other. For pieces like this, I focus on good silhouettes for composition before I flesh out the details. I used very thin lines so the coloring would carry most of the definition of the image. I chose cool blue for the shading to contrast the warm peach lighting.

Saul
PaintTool SAI and Adobe Photoshop

As a longtime comic book reader, I've always liked dark, bold shading and sometimes I apply it to my work. The heavy shadows bring out the intense, brooding qualities of the subject and also make the colors appear more radiant in comparison. Simple, flat coloring works well with this style.

Artist's Toolkit

Most of the art I do is entirely digital. I start by making preliminary sketches in PaintTool SAI to work out my ideas and composition. I generally work at larger resolutions (at least 300 dpi) for printing purposes. I create the line art by inking over an unrefined sketch. I like to keep my lines loose so I don't lose the movement in the piece. Sometimes if I go too detailed on the sketch, the finished line art becomes a little stagnant. I aim for a spontaneous look rather than controlled and overly disciplined lines.

When the line art is complete, I carry the file over to Photoshop for the coloring. My coloring tends to be angular, like my lines, to complement the overall sense of animation I want my work to have. I make heavy use of the Lasso tool to create bold shadows. Additional textures and brush accents are usually an afterthought, and I don't always use them, but they can help give a more traditional look to a piece.

Materials list

- Adobe Photoshop
- Computer with plenty of memory and hard disk storage
- Mirror or webcam (for referencing facial expressions)
- PaintTool SAI
- Paper (for texturing)
- Scanner
- Wacom Graphics Tablet

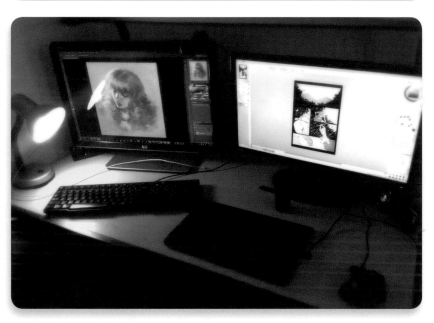

Work Space
This is my computer setup. I use a small tablet to conserve space for when I want to draw on paper. My dual monitor displays help with multitasking. For example, you can display reference images on one screen while working on the other.

DPI

DPI stands for Dots Per Inch. In artist terms, it's a measurement of how many pixels are present in a printed or scanned 1" (3cm) line. Generally, 300 DPI is the setting for professional printing. That means it takes 300 pixels of data on screen to equal 1" (3cm) of printed art. If you take that idea, you'll see that to print a high-quality image on an 8.5" × 11" (22cm × 28cm) piece of paper, your art will need to be 2400 × 3000 pixels, leaving some space for margins. (For math fans, the formula is simple: 2400pixels ÷ 300DPI = 8.0 inches) As you can see, if you intend to print your art and have it look great, you'll need to work fairly large on screen. That's where all the memory and hard disk storage comes in handy.

PaintTool SAI Ink Pen settings for line art.

PaintTool SAI Pencil brush settings for sketching.

Using Paper Texture

Paper texture is a great way to add a grainy quality to your art and diminish the smooth, artificial appearance of digital coloring. You can scan any paper that has a pattern you like, or get it from a website with downloadable textures. Then simply place the paper texture on an Overlay layer above your artwork to add texture to the piece. Adjust the opacity and color of the paper to your liking.

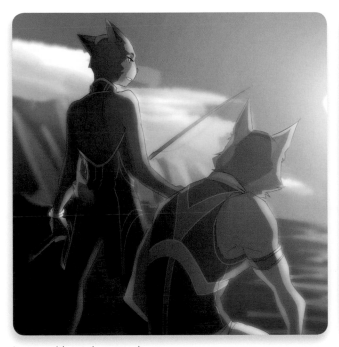

Image without the paper layer.

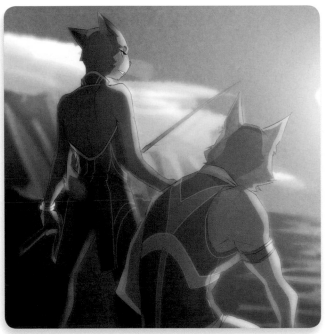

Image after adding the paper layer.

In this demonstration, I'll show you how to draw a character in a stationary pose that shows off his personality. This involves playing with camera angles as well as exaggerating mannerisms to give the character more attitude. Our subject is a male tiger wearing French Revolution-era clothing. I chose this style of clothing because I wanted something that portrayed confidence and suited the tiger's powerful image.

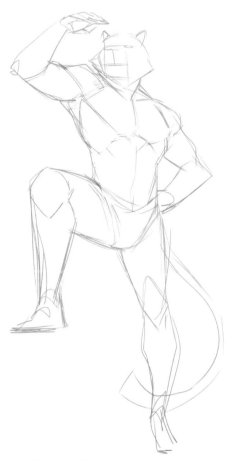
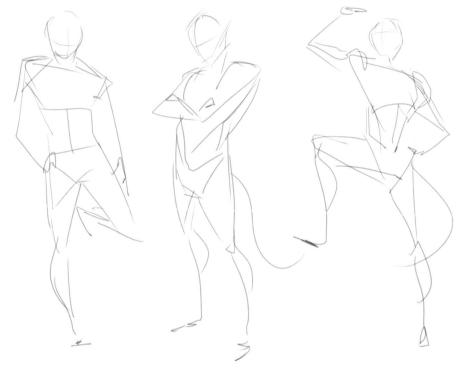

1 Study the Action
Start by making some quick gesture sketches to get down some pose ideas. Try playing with camera angles as well as exaggerating mannerisms to give the character more attitude. If you're working digitally, use the Pencil brush in PaintTool SAI set on a midrange density. This part can also be done on paper if you prefer.

2 Sketch the Figure
Once you decide on the pose, roughly flesh out the anatomy. For male forms, it's best to use angular lines to give a strong and confident feel to the structure. Use the swish of the tiger's tail to add flow through the image and make the piece look more animated.

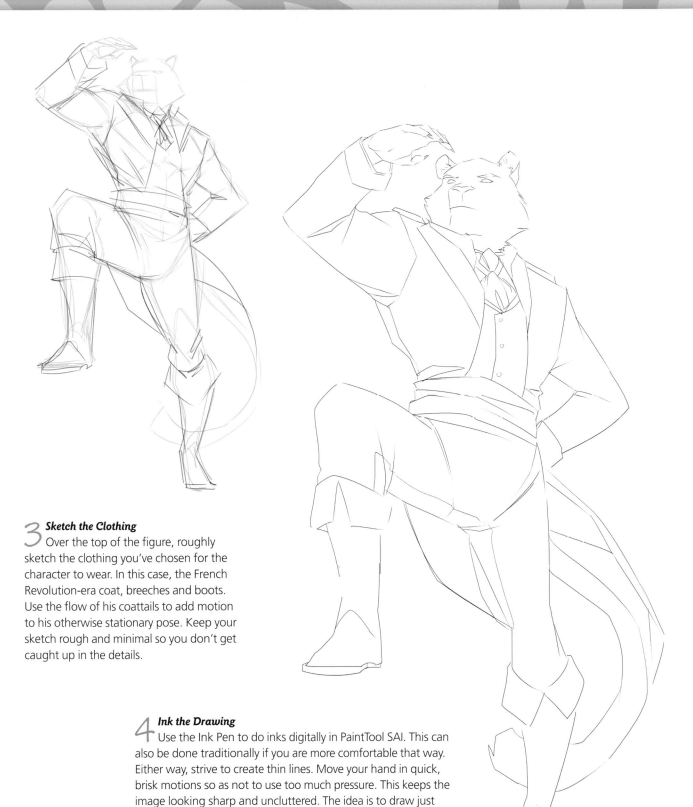

3 Sketch the Clothing
Over the top of the figure, roughly sketch the clothing you've chosen for the character to wear. In this case, the French Revolution-era coat, breeches and boots. Use the flow of his coattails to add motion to his otherwise stationary pose. Keep your sketch rough and minimal so you don't get caught up in the details.

4 Ink the Drawing
Use the Ink Pen to do inks digitally in PaintTool SAI. This can also be done traditionally if you are more comfortable that way. Either way, strive to create thin lines. Move your hand in quick, brisk motions so as not to use too much pressure. This keeps the image looking sharp and uncluttered. The idea is to draw just enough lines to get down the basic structure.

Time to color and add details to our dignified tiger. I wanted his clothing to have blue in it to complement the orange of his fur. The French Revolution-era clothing is great for that reason. I included shades of red and yellow in other parts of the design to echo the orange fur. Finally, the brown for the boots and stripes contains blue, red and yellow so they work well with the rest of the palette.

If you're working in PaintTool SAI, save the inked art as a PSD so it can be brought into Photoshop for coloring. Open the file in Photoshop and lock the line art layer's transparency. This makes it easier to change the color of the lines if you wish. I tend to use a color lighter than black for my lines. It isn't necessary to do this, just personal preference, but I find it allows the coloring and shading to bring volume to the character and lets the lines play a supporting role instead.

If you are working traditionally, scan the image and bring it into Photoshop for coloring. Set the line art layer to Multiply, or select and remove all the white area to create line art with transparency that can be locked just like digital line art.

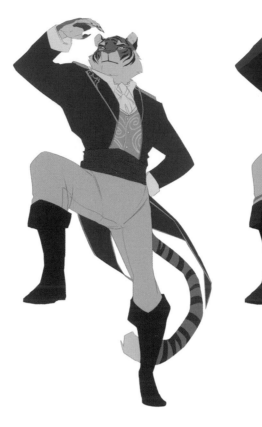

1 *Flatting*
Start by laying down your base colors (also known as flats) on a separate layer under the line art. This layer should be set to Normal. Clean up any colors that go outside the lines. When you're done, lock the transparency of the layer to keep your brushstrokes contained.

2 *Add Shading*
On top of the Flats layer, create a Multiply layer for shading and detailing. Then load your Flats layer as a selection and convert the selection into a layer mask around the Multiply layer. This way, all of your shadow painting stays within the lines. For the shadows I used a light blue color that is lighter than the line art to bring out the warmer colors. You can use either a standard Hard Round brush to manually apply them or the Lasso tool to select and fill an area with color.

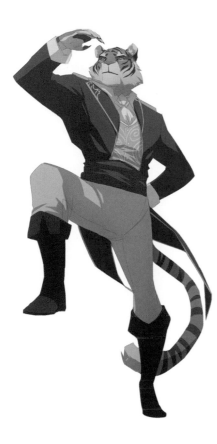

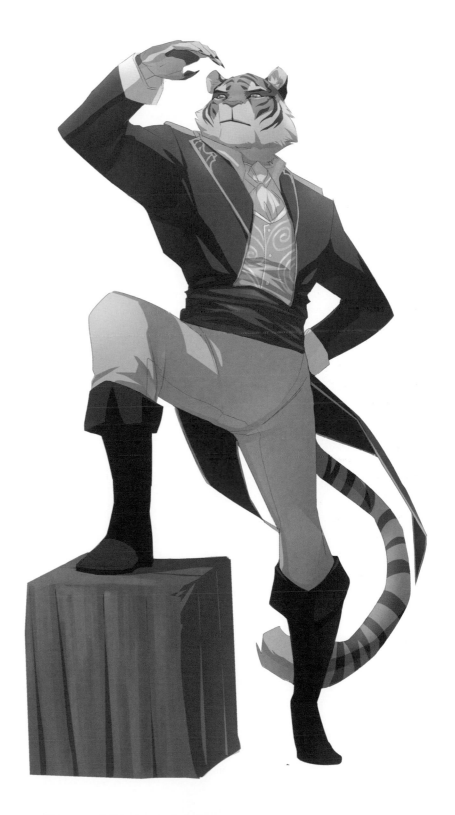

3 Apply Tone and Texture
Create an Overlay layer on top of all the other layers. Again, select the Flats layer to create a mask around your lines. Apply a gradient or a flat wash to set the mood and add more tone to the coloring. I used a light purple and orange gradient over the character to make him appear warmer. Use a Paper Overlay layer to add texture.

4 Finishing Touches
Using a soft Airbrush tool on low opacity, apply additional shadows and highlights on the Flats layer to soften the colors. Imply reflected light from the environment by lightly brushing ambient blues onto the downward-facing shadow areas. Finally, to give the tiger a sense of setting, add a wooden crate beneath his lifted leg.

For this demo, I will show you how to draw a character in an active pose. I'll also demonstrate a few tricks to help give the image a sense of motion. When drawing animals known for certain physical abilities, you can use those attributes as a source of inspiration for the pose.

Try to play up to their strengths and show them doing what their bodies are built for. Our subject is a grizzly bear, known for its strength, size and quick bursts of speed. So making the character into a well-built athlete, like an American football or rugby player, is a good fit.

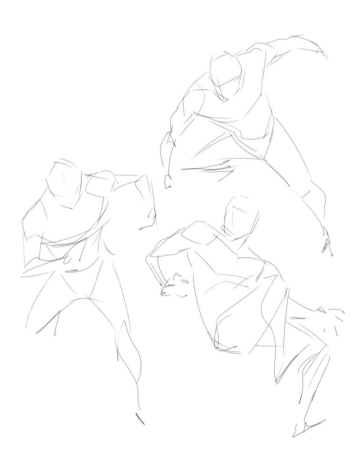

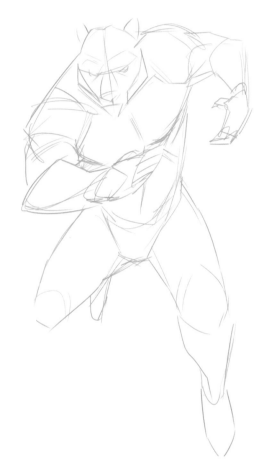

1 *Study the Action*
Start by making some rough action poses for brainstorming. Use the Pencil brush in PaintTool SAI, or sketch on paper if you prefer. Before I start sketching, I like to watch videos of the motion I want the character to portray. Pictures are useful too, but videos can help you better understand the action and the physiology of the subject while he's performing.

2 *Sketch the Figure*
After you are satisfied with a pose, add anatomy to the frame. Use angled lines for masculine builds to bring out a more solid-looking frame. This character has a larger-than-average build, so bulk up his muscles and proportions accordingly. As you build up the figure, try to push the foreshortening of the pose (the forward-swinging arm, the backward-kicking leg) to add to the character's motion.

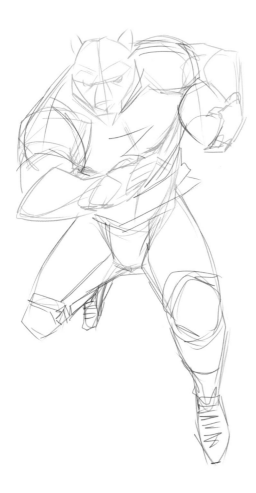

Fun Facts

Conventions celebrating furry fandom can be found all over the world. The largest is Anthro-con, held in Pennsylvania, USA.

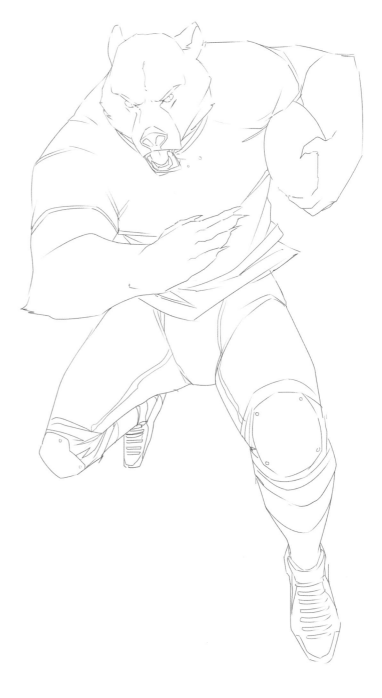

3 Sketch the Clothing

Sketch the clothing on top of the body sketch. A sports uniform needs to be easy to move around in and doesn't produce a lot of drag when running, so keep it streamlined. Because this character is in an active pose, pay attention to how the outfit behaves while the body is in motion. Again, pictures and videos will help greatly.

4 Ink the Drawing

Use the Ink Pen in PaintTool SAI or work traditionally if that's more comfortable. Keep the strokes thin to let the colors in the next step bring volume to the character. Aside from establishing the basic structure, lines are important for directing the flow of the character's movement. If the character is moving to the left, your strokes should go left to right on parts that are most affected by the movement (the bear's lower lip, shirt, ears, etc.). Flip or rotate your image as necessary to aid in getting the proper directional pull to your lines.

Bear: Coloring

Now let's color our star athlete. If you are working traditionally, scan your line art. If you are working in PaintTool SAI, be sure to save it as a PSD file. From here, we'll import the image into Photoshop and apply color to add volume and detail to the figure. I've selected yellow and black for his team uniform, a typical and appealing combo that goes well with the bear's brown fur, but any color combination you like is fine.

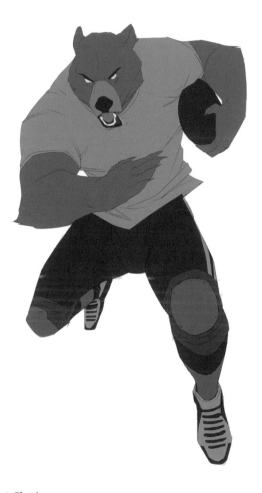

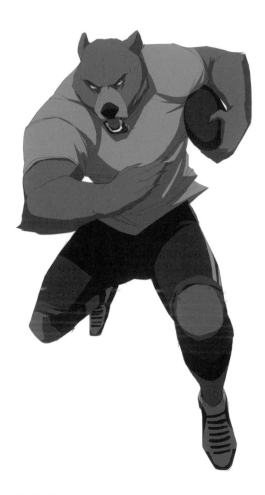

1 Flatting

In Photoshop, lock the line art layer's transparency and change the lines to a color lighter than black. Then make a layer beneath the line art, set to Normal, and start laying down your flats. Work carefully, making sure to stay inside the lines. Often it's helpful to outline a section with a brush and then use the Paint Bucket tool to fill it with color. Once the flat colors are in place, lock the transparency to contain any further brushstrokes.

2 Add Shading

On top of the Flats layer, create a Multiply layer for shading. Use shadows to express form and bring attention to his face. I used a light violet for the shadows to give contrast to the yellow tones of the character. You can use either a Hard Round brush to manually apply them or the Lasso tool to select and fill an area with color. Be sure your shadows do not go outside the lines.

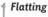

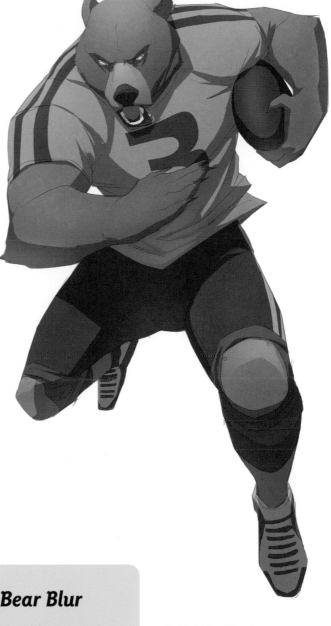

3 **Additional Shading**
Make another Multiply layer and use a darker brown tone to carefully draw the stripes and number on his uniform. On the Flats layer, using a soft Airbrush tool on low opacity, add more variations in highlights and shadows. You can also add secondary lighting to heighten the sense of volume.

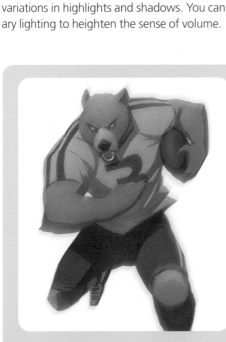

Optional Bear Blur

You can add motion blur to your image by using the Motion Blur filter in Photoshop. I recommend first merging your image down, duplicating the layer and then using the filter on the second copy. After that, lower the opacity to produce an image that appears blurred by the character's motion. If you want, you can selectively erase parts of the blur layer to vary the intensity of motion or create a focal point.

4 **Finishing Touches**
Use a ruddy purple gradient over the bear to make him appear warmer. If desired, you can add texture with a paper layer set to Overlay.

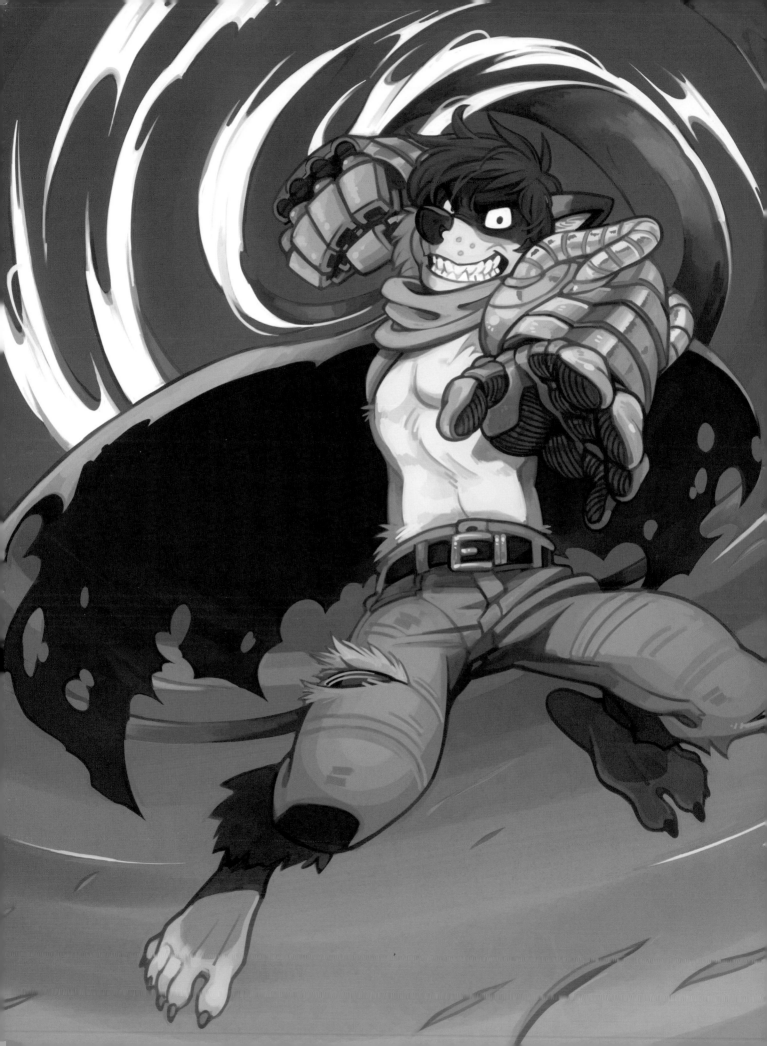

CHAPTER EIGHT
Alexander Håkansson

Alexander Håkansson was born and raised in the Swedish countryside. He picked up art in his early years, drawing characters from his favorite video games, cartoons and comics. His interest in visual mediums kept him drawing as a hobby throughout his school years, which eventually led to his decision to pursue art as a career. After high school, Alexander went to college to study under the Comics and Graphic Storytelling program in Gävle. Always making new friends with a similar interest, he continuously aims to develop his skills and grow as an artist.

Preemptive Strike
Digital

Style

As a kid, I used to read through the manuals of my favorite video games like Super Mario Bros. and Mega Man. I was caught up looking at the character art, often trying to draw them myself. To this day, I still enjoy dynamic and fun characters the most, with simple but believable expressions.

I've always put a large emphasis on clean line work, picking up inspiration from Japanese comics during my junior high school years and later turning my attention to Western animation. Trying to combine the best of both worlds, I aim to convey immediate emotions and atmosphere using a simple but effective approach.

Sally Mander
Digital

I created this image as practice for colors and a method of painting. The hint of red in the line work brings warmth to the character. It was a happy accident—I was merely eyedropping colors in Photoshop while using a red background to complement her color scheme.

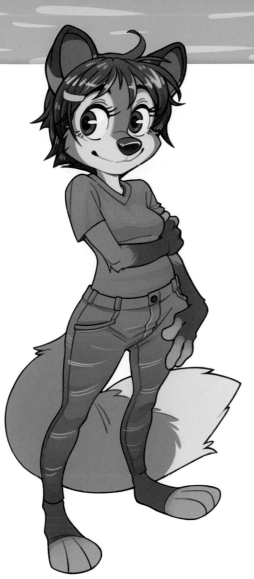

Lennart the Iguana
Digital

Lizards are happiest when basking in the sunlight! I made this image as a practice piece to develop my iguana character.

Fox Trade
Digital

This was done as an art trade for a friend. When drawing other artist's characters, I like trying to mix the style of both myself and the original creator.

Autumn Wind
Digital

The original idea was to make something static yet dynamic. Her pose is fairly calm but drawn with a great deal of three-dimensional overlap. Meanwhile, the blowing wreath of leaves imparts motion to the composition.

Artist's Toolkit

Being almost exclusively a digital artist, I think my process definitely reflects that. With a theoretically unlimited canvas and supply of layers, I sketch with big shapes and a thick pencil brush. I've adapted to a wide brush with a uniform line weight for sketching as a way to not get caught up in details early on, but rather to build up and view an image as a whole. I often clean up my sketches at least once by pulling down the opacity of the current layer, then creating and drawing on a new layer on top of the previous one. The use of layers and opacity emulates the use of a light table, enabling me to continue without losing any of my previous lines.

While some artists may like to use many layers, I try to limit myself to as few as possible. I keep separate layers for sketches, inks and colors but rarely go beyond those basic few. I fill in my colors below the line work and add additional detail and effects afterward. Most of my process is done in PaintTool SAI due to its simplicity and straightforward approach. I use it in combination with Adobe Photoshop but mostly for exporting to different file types.

Sketchbooks are good for whenever you can't take your computer with you.

Materials list

- PaintTool SAI
- PhotoShop CS4
- Wacom Intuos5 Touch

Intuos5 tablet

Work Space

Because I do most of my drawing on the computer, the layout of my work space is fairly simple: a desk, a nice desktop computer with a good amount of RAM and a large screen, a comfortable and adjustable chair and, of course, a drawing tablet. I try to keep the rest of my desk unoccupied for the times when I have the itch to sketch traditionally. If I end up with something I want to finish digitally, I always have a scanner close at hand.

Fun Facts

Some of the most popular animals in the furry fandom include foxes, wolves, dogs, dragons, cats and tigers.

As with most fish, sharks can be a bit tricky to anthropomorphize. I blame this on the fact that they don't have a clear neck and the shape can be hard to translate into a human form. Because of this, I personally tend to give sharks a very wide neck and broad shoulders.

There are many variations of sharks, but for this tutorial, we are going to go with the porbeagle. Besides the classic shark look, it has large and obvious eyes, a pointy nose, a firm and stubby tail and well-defined body markings. You should always try to pick out prominent features of the species and think of how to use them for your characters.

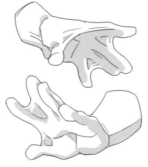
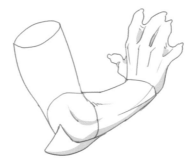

Hands and Fins
The extremities of anthro sharks can look all human or take inspiration from the fins. Webbed hands or a fin sticking out from the elbow further emphasizes your character's aquatic nature.

Example of a Porbeagle Character
Shark characters don't necessarily have to be menacing! Go against expectations for interesting results.

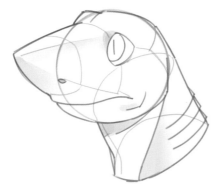
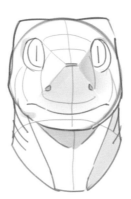

Head Shape
Practice sketching your subject from various angles to better understand how it works in three dimensions. Shark heads are awkward when viewed from the front, so take some liberties with the shape for a readable expression.

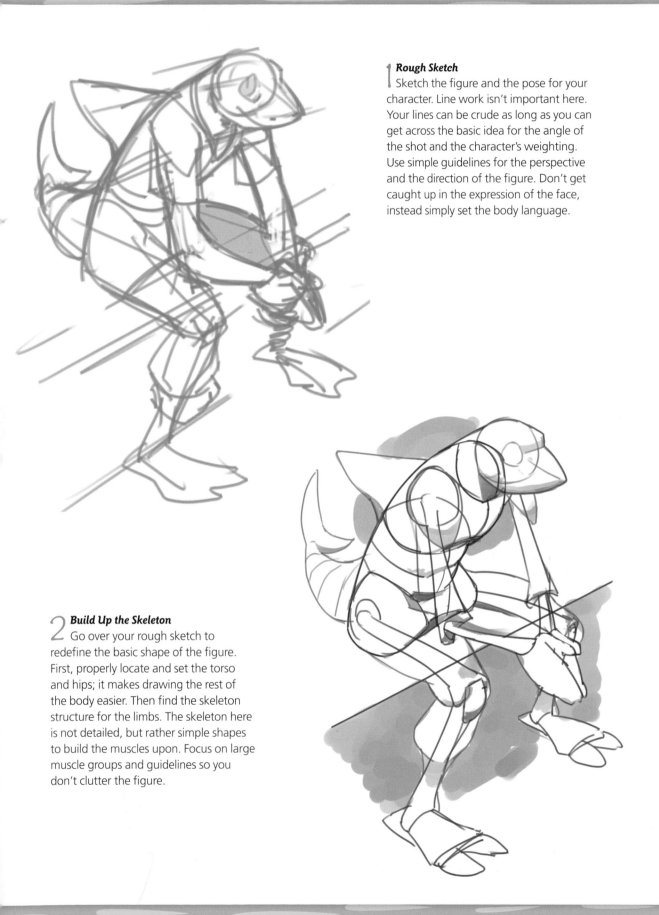

1 Rough Sketch

Sketch the figure and the pose for your character. Line work isn't important here. Your lines can be crude as long as you can get across the basic idea for the angle of the shot and the character's weighting. Use simple guidelines for the perspective and the direction of the figure. Don't get caught up in the expression of the face, instead simply set the body language.

2 Build Up the Skeleton

Go over your rough sketch to redefine the basic shape of the figure. First, properly locate and set the torso and hips; it makes drawing the rest of the body easier. Then find the skeleton structure for the limbs. The skeleton here is not detailed, but rather simple shapes to build the muscles upon. Focus on large muscle groups and guidelines so you don't clutter the figure.

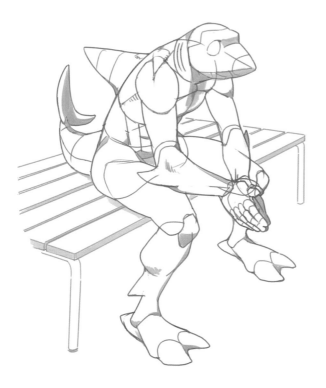

3 Define the Anatomy

Clean up the character enough to make the anatomy readable. This is mainly to make sure you've kept track of the limbs and the weight. Check the proportions (for example, comparing sizes of body parts) and correct any mistakes.

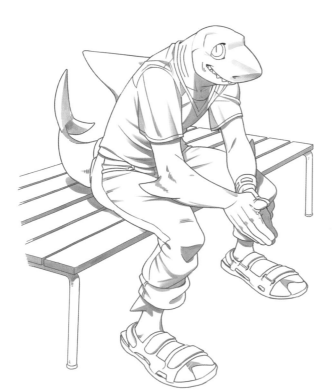

4 Sketch the Clothes

Roughly sketch the clothes over the figure. The red arrows indicate the direction the fabric is pulling. Remember that clothes follow the form and have a weight of their own. They connect at the seams and hang down, tugged by gravity—keep this in mind when drawing folds and creases. When a character leans forward, the shirt doesn't stick to the body; instead it hangs a bit, producing space between the chest and the fabric.

5 Ink the Drawing

Create a new layer on top of your sketch and lower the opacity of the sketch layer. The way you ink sets the style for your picture. For this particular picture, we'll be coloring with a more painterly touch, so use a smoother, lighter brush instead of a jet-black brush to make the lines less prominent. With this method, you can also add shadows at this stage, either on the same layer or on a new one.

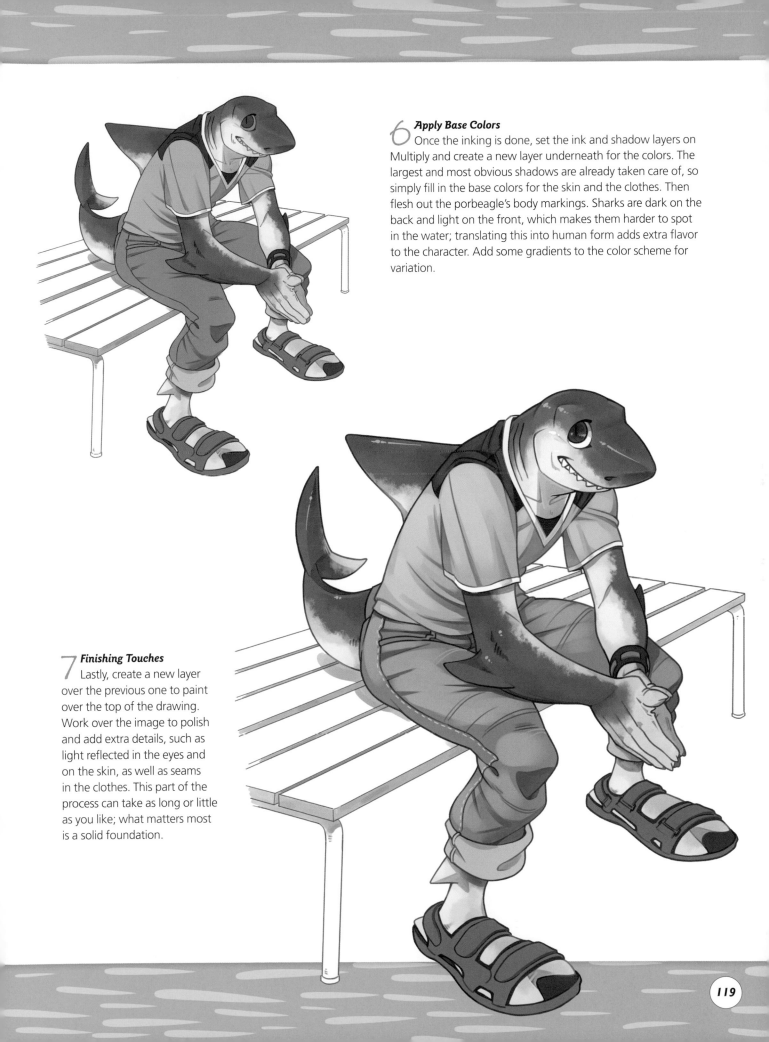

6 Apply Base Colors

Once the inking is done, set the ink and shadow layers on Multiply and create a new layer underneath for the colors. The largest and most obvious shadows are already taken care of, so simply fill in the base colors for the skin and the clothes. Then flesh out the porbeagle's body markings. Sharks are dark on the back and light on the front, which makes them harder to spot in the water; translating this into human form adds extra flavor to the character. Add some gradients to the color scheme for variation.

7 Finishing Touches

Lastly, create a new layer over the previous one to paint over the top of the drawing. Work over the image to polish and add extra details, such as light reflected in the eyes and on the skin, as well as seams in the clothes. This part of the process can take as long or little as you like; what matters most is a solid foundation.

DEMONSTRATION
Leopard Gecko

As the name suggests, the leopard gecko is a yellow gecko with black dotted markings covering its body. Although large for a gecko, it's still a small, crawly critter compared to many reptiles.

Being almost cartoonish in its proportions already, it has a large head and a tail that bulges in the middle. The tail is big as a means to store fat, but it can be smaller or shorter to better fit the character. Perhaps it can be used as a personal trait—the character won't get chubby around the belly because it all goes to the tail, or it might be a health nut with a thin tail. Fables have long used animal traits to convey personality; adding your own twist is half the fun with anthropomorphic characters!

Gecko Tail
Too big for comfort? A chubby tail can be a fun body trait, but think of how it's attached and how the clothing fits around it.

Gecko Example
Unlike most gecko species, leopard geckos have eyelids, though choosing not to depict them can make the characters appear even more excited and energetic. The bright color scheme also adds to their cartoony appeal.

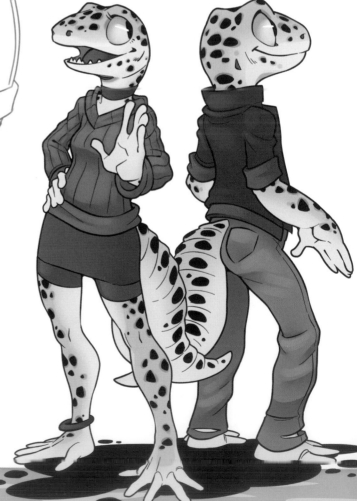

1 Rough Sketch

Begin with a rough draft of the character. Focus most of your attention on drawing the pose figures. Use simple lines and shapes to block in clothes and accessories to ensure they don't ruin the composition later on. Keep track of the perspective by adding a light grid or shadow. This will help you visualize your character's weight distribution on the ground.

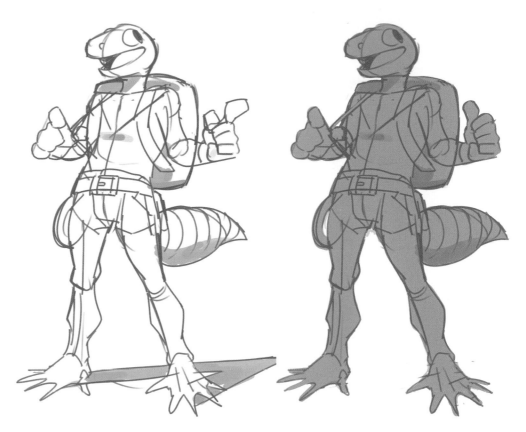

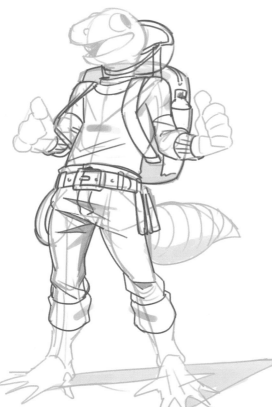

2 Silhouette Check

An easy but effective way to check your work at this stage is to look at the silhouette. If the character's pose is too cluttered or busy, you won't be able to easily read the drawing. This can be done quickly by making a new layer and blacking out the character or by adding a dark tone over the line art. Can you still tell what the character is doing? Look at the negative space and make any necessary edits. Don't be afraid to redraw limbs or other parts if it will improve the pose's readability.

3 Sketch the Clothes

Following the form of the body, add folds to give the clothes some definition. Don't get carried away, however, because too many folds will cause the clothing to look baggy and overly busy. Finding a balance that works takes practice but pays off in the long run. Also, remember that clothes describe personality, too! Whether it wears regular clothes or is dressed for an occasion or activity—the clothing immediately tells us more about the character.

4 Refined Sketch

Create a new layer and do a final pass to clean up your drawing for inking. How refined you make your sketch depends on how confident you are in your inks. A cleaner sketch reduces guesswork and leaves more room for freedom while inking—it's all up to personal taste.

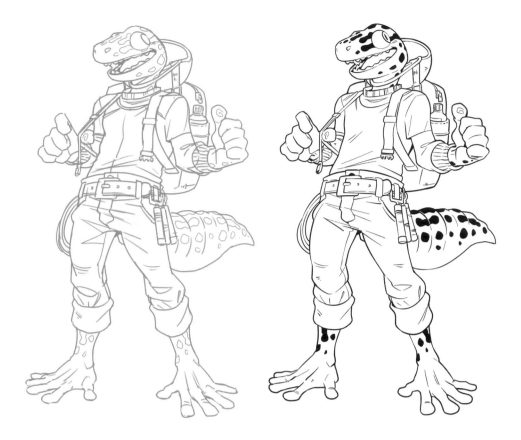

5 Ink the Drawing

Select an inking brush and begin inking on a new layer, following the sketch. Choose a style of inking that complements the way you plan to color your image. For a bright, cartoony color treatment, bold black lines work well. Use heavy strokes to define the overall body and a smaller brush for details. Consider filling certain details in black (like the gecko's spots) instead of coloring them to give them impact.

6 Apply the Base Colors

There are several ways to approach coloring. One way is to start by filling the character with darker shadow colors first, then building up to brighter tones in the next step. Or you can go the opposite direction and start with lighter colors and paint your shadows in afterward. Both techniques work equally well. Character designs with too many colors can be confusing unless they're balanced and limited. If you can't decide on a color for something, consider picking from ones you've already used.

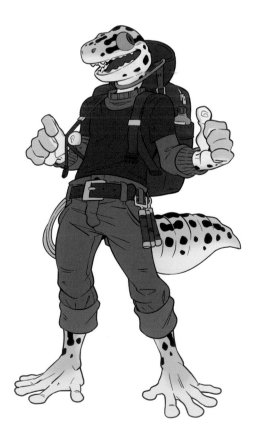

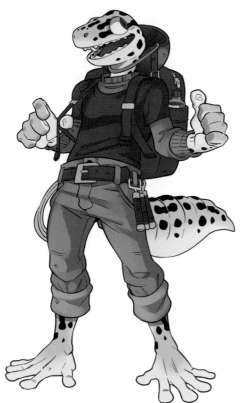

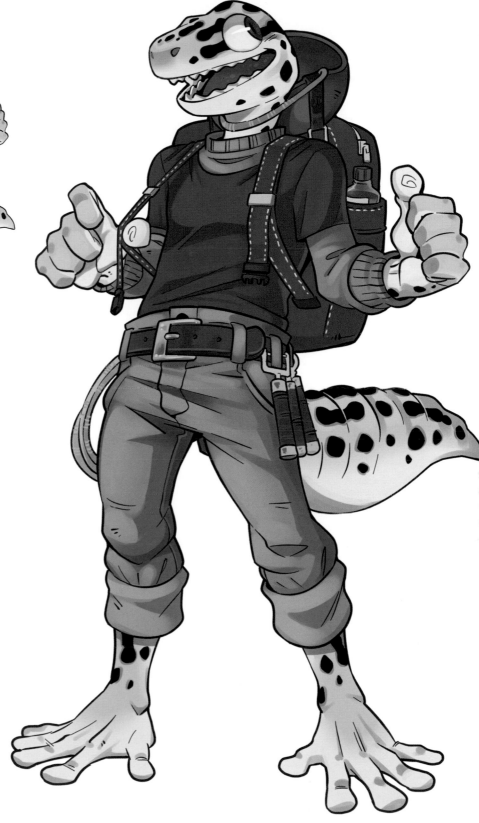

7 Adding Light

When all the parts are filled in, use brighter colors to paint over the shadows. Follow the form and visualize how the light falls on the figure, both on details and the character as a whole. When painting dark to light, I tend to use a softer brush, controlling the density with the pen pressure. To create subtle gradients between light and dark, softly stroke toward the dark areas with the pen. Add additional shadow tones where necessary.

8 Finishing Touches

Continue to build up the light areas until you have a satisfying contrast. Add a new layer on top for finer detail and minor edits on the drawing. When painting digitally, it can be convenient to play around with the hue and saturation, either for selected parts or the whole image. Try adjusting the color levels for some post-editing touches. You'll be surprised by how much a drawing can change by simply adjusting a color!

Index

About the Authors

Lindsay Cibos and Jared Hodges are an artistic duo specializing in illustrations and sequential art. They are the creators of the graphic novel series *Peach Fuzz*. Lindsay and Jared have also authored several art tutorial books including IMPACT's *Draw Furries*, recipient of the 2009 Ursa Major Award for Best Other Literary Work, and *Draw More Furries*. They currently reside in sunny central Florida. Visit them on the web at www.jaredandlindsay.com.

Acknowledgments

The contributing artists, Katie Hofgard, RUdragon, Kristen Plescow, CookieHana, Tyson Tan, Kathryn Layno and Alexander Håkansson, for their outstanding work and for graciously sharing insights into their work methods.

Everyone at F+W Media, especially our editor, Brittany VanSnepson, for her help and encouragement. Also, to Laura Yoder and Hannah Bailey for beautifully arranging the art and words into book form.

Our families for their love and support, as always.

The furry community for their enthusiasm for the project and invaluable feedback.

And a very special thanks to you!

Visit impact-books.com/furries-furever for this **FREE** furrie step-by-step demonstration, cool wallpapers and a designer's guide for creating your very own fursona!

Contributing Artists

Lindsay Cibos
Location: USA
Websites: lastpolarbears.
com, jaredandlindsay.
com
E-mail: LCibos@jaredan-
dlindsay.com

Kristen Plescow
Location: USA
Websites: kristenple-
scow.tumblr.com,
furaffinity.net/user/cen-
tradragon

Alexander Håkansson
Location: Sweden
Websites: bockom.
blogspot.se, manalon.
tumblr.com, furaffinity.
net/user/analon
Email: alexander.hakans-
son88@gmail.com

RUdragon
Websites: phation.
deviantart.com,
furaffinity.net/user/
rudragon

Katie Hofgard
Location: USA
Website: katiehofgard.
daportfolio.com
E-mail: khofgard@gmail.
com

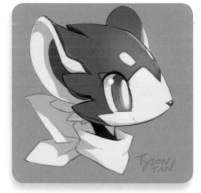

Tyson Tan
Location: People's
Republic of China
Website: tysontan.com,
tysontan.deviantart.com

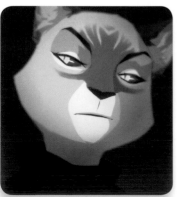

**Kathryn Layno
(denimcatfish)**
Location: Philippines
Website: kathrynlayno.
deviantart.com

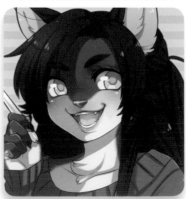

**Jennifer Lynn Good-
paster Vallet
(CookieHana)**
Location: Seville, Spain
Websites: cookiehana.
deviantart.com, furaffin-
ity.net/user/cookiehana
E-mail: cookiehana@
hotmail.com

 Other fine IMPACT Books are available from your favorite bookstore, art supply store or online supplier. Visit our website at fwmedia.com.

18 17 16 15 14 5 4 3 2 1

DISTRIBUTED IN CANADA BY FRASER DIRECT
100 Armstrong Avenue
Georgetown, ON, Canada L7G 5S4
Tel: (905) 877-4411

DISTRIBUTED IN THE U.K. AND EUROPE
BY F&W MEDIA INTERNATIONAL LTD
Brunel House, Forde Close, Newton Abbot, TQ12 4PU, UK
Tel: (+44) 1626 323200, Fax: (+44) 1626 323319
Email: enquiries@fwmedia.com

DISTRIBUTED IN AUSTRALIA BY CAPRICORN LINK
P.O. Box 704, S. Windsor NSW, 2756 Australia
Tel: (02) 4560-1600; Fax: (02) 4577 5288
Email: books@capricornlink.com.au

ISBN 13: 978-1-4403-3441-2

Edited by Brittany VanSnepson
Designed by Laura Yoder and Hannah Bailey
Production coordinated by Mark Griffin

Metric Conversion Chart

To convert	to	multiply by
Inches	Centimeters	2.54
Centimeters	Inches	0.4
Feet	Centimeters	30.5
Centimeters	Feet	0.03
Yards	Meters	0.9
Meters	Yards	1.1

Credits

(8) *Precipice of Light* was commissioned by David Benaron.

(10) *Azzari Portrait* was commissioned by AzzyBlue.

(11) *Challenge Accepted* character belongs to and was commissioned by Jenine Herrell.

(11) *Cortez* was commissioned by Suntattoowolf.

(11) *Toffee* was commissioned by C. Hardin.

(18) *Dawn of a New Era* (Rule of Thirds example) was commissioned by Lionel.

(18) *The Last of The Wilds* (Dark and Light example) was commissioned by Sharlan.

(68) *Sakiko* character belongs to Kcravenyote.

(70) *Shizuka* character belongs to Kcravenyote and was designed by Luckypan.

(71) *Evyn* character belongs to MagicBunBun. The Fionbri species was designed by Summer Gagnon.

(71) *Nyx* character belongs to Neverfilledvoid.

(73) *Safiyah* character belongs to Skimike and was designed by Magenta.

Ideas. Instruction. Inspiration.

Download a FREE furrie step-by-step demonstration at impact-books.com/furries-furever.

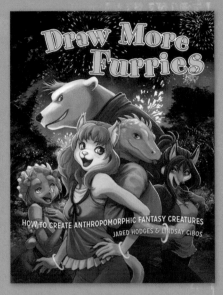

Check out these **IMPACT** titles at impact-books.com!

These and other fine **IMPACT** products are available at your local art & craft retailer, bookstore or online supplier. Visit our website at impact-books.com.

Follow **IMPACT** for the latest news, free wallpapers, free demos and chances to win FREE BOOKS!

Follow us!

IMPACT-BOOKS.COM

▶ Connect with your favorite artists
▶ Get the latest in comic, fantasy and sci-fi art instruction, tips and techniques
▶ Be the first to get special deals on the products you need to improve your art